A
Chin
Mirror

A Chinese Mirror

Moral Reflections
on Political Economy
and Society

Henry Rosemont, Jr.

OPEN COURT
La Salle, Illinois

Cover photos: on the left, the entrance to the Forbidden City directly across from the Square, late May 1989; on the right, children with umbrella, street scene in Xian, June 1991. The children's photo is courtesy of JoAnn Rosemont, the Forbidden City, courtesy of Lisa Scheer.

This book has been reproduced in a print-on-demand format from the 1991 Open Court printing.

To order books from Open Court, call toll-free 1-800-815-2280 or visit our website at www.opencourtbooks.com.

OPEN COURT and the above logo are registered in the U.S. Patent and Trademark Office.

© 1991 by Open Court Publishing Company

First printing 1991

Printed and bound in the United States of America.

Library of Congress Cataloging-in-Publication Data

Rosemont, Henry, 1934–
 A Chinese mirror: moral reflections on political economy and society/Henry Rosemont, Jr.
 p. cm.
 Includes bibliographical references and index.
 ISBN 0-8126-9161-X (cloth). —ISBN 0-8126-9162-8 (pbk.)
 1. China—Politics and government—1976– 2. Political ethics—China.
3. China—Economic conditions—1976– 4. Business ethics—China.
5. China—Social conditions—1976– 6. Social ethics. 7. Individualism.
I. Title.
DS779.26.R66 1991
951.05'8—dc20 91-29013
 CIP

To JoAnn
My fair mirror; and much more

Contents

Acknowledgements

Some of the ideas treated in these pages were first raised in a short article I wrote for *In These Times* (August 8, 1989) after returning from Beijing. A much expanded version was published in *Z Magazine* (March, 1990), and the responses to the latter article prompted continued expansion and augmentation of the work to its present form. I am grateful to those respondents for their criticisms and encouragement, most especially to Professor Herbert Fingarette, who first suggested that the materials be presented as a small book.

An early version of Chapter III was read at a Symposium on Human Rights in China at Columbia University in January, 1991, and given as a lecture at the Center for Chinese Studies at the University of California, Berkeley, and to the Philosophy Department at Humboldt State University, in March. Again, I am grateful for both criticisms and encouragement from those audiences.

At St. Mary's College of Maryland, the students in my Philosophies and Religions of Asia courses have been splendid sounding boards, and critical listeners for a number of philosophical ideas contained herein; it is largely due to them that I continue to be both proud and happy to be a teacher. The Faculty Development Grants Committee twice provided travel subventions to assist my later visits to China, and I am grateful for that assistance. I owe a very large debt to Mrs. Gail Dean of the Provost's Office for quickly and efficiently transforming my scrawled longhand pages into beautifully typed chapters, and to Mrs. Linda

Vallandingham of the Division of Human Development, for doing the same with the Notes and References; an author could not ask for better aid and assistance than I have received from them—with wit and humor to boot. I also owe a long-running intellectual debt to my colleague James Nickell, Professor of Political Science, with whom I have most profitably and enjoyably team-taught seminars in Political Theory and in Philosophy of Religion for the past decade. Special kudos go to another colleague, Professor Lisa Scheer of the Art Department. A sculptress of note, she is also a first-rate photographer (and a boon traveling companion), as the pictures which grace these pages attest.

Closer to home, I am grateful to my daughter Samantha Rosemont for undertaking the labor of preparing a useful index, and to my wife JoAnn for the children's picture on the cover of this book. I am also grateful for their support— and the support of the rest of my family—while this work was in progress.

At Open Court, David Ramsay Steele has continued to combine strong support for my efforts in general with strong critiques of particulars, and I am indebted to him for both. And I am again delighted to have had Dr. Kerri Mommer as my editor; her careful eye spots vagueness and nonsense as quickly as misprints, and this work is much the better for the care and skill with which she prepared it for the printer.

My debt to the Chinese peoples is incalculable.

All of the above have helped me a great deal and are responsible for much that may be good in this book, but are blameless for its shortcomings.

<div align="right">H.R.</div>

Spring Ridge, MD
August 1991

Introduction

Although this book deals largely with contemporary China, it was not written either as a treatise in sinology or as an exercise in any of the social, behavioral, or decision "sciences." Nor is it intended simply as a book on current affairs. I am a philosopher by trade, and philosophical views, especially moral views, permeate the work. But as a philosophical book, both its style and content are at wide variance with most of the paradigms regnant in the discipline.

If the present work must be categorized, it is probably best described as an essay in applied comparative philosophy. I have attempted to place in proximity to each other a number of facts, figures, and observational reports on contemporary China—with claims to accuracy, if not completeness or systematicity—in order to present a picture of the current state of affairs there, a picture differing in many respects from the others that have been drawn, and I have attempted to do this in such a way as to not merely portray the circumstances and dilemmas confronting the Chinese peoples, but also to serve as a mirror of the circumstances and dilemmas facing the American peoples as well, especially those who live a middle-class or better material existence in the United States.

Hence the work will surely be seen as partisan, which I accept; I can't imagine anyone being neutral about most of the issues and problems considered herein. But partisanship does not entail an unbalanced account (although some will surely see it that way); on the contrary, one of my major purposes in presenting it was to offer a balance to what I regard as ideologically skewed standard accounts, accounts that are all too common in sinological scholarship on contemporary China, and in the commercial television and print coverage of the country.[1]

In general, whenever Republicans, Democrats, and the standard media in the United States, in concert with the governments of other capitalist industrial democracies, agree fully in their analyses and evaluations of the actions and policies of a developing country, it is cause for concern on the part of everyone committed to struggles for peace and justice in general, and in that developing country in particular. For the most part, alternative analyses and evaluations are fairly ready to hand: appalled by the illegal and immoral invasion of Panama, we could call for a policy of strict non-intervention; saddened by continued governmental support for the contras, Israeli "defense" forces, and Arena, we could advance the legitimate claims of the Sandinistas, PLO, and FMLN; angered by the slow pace of negotiations with the Soviets, or with South Africa, we can press for more serious dialogue with the former, more serious sanctions against the latter. And we can continue to condemn the invasions of Kuwait, and then Iraq, for the aggressive wars they were, comparing Saddam Hussein not to Hitler, but to George Bush.

On the subject of China, however—towards which the

denunciations have been almost as unanimous as they have been shrill for the past two years—there seems to be little to say in opposition. The silence is understandable. Any attempt to counter the continuingly misleading picture of China presented by the U.S. media, or to mute the calls for vengeance that have issued from the House and Senate, will at best place a person in the Bush/Kissinger camp of *Realpolitik,* or, at worst, be construed as a defense of the brutal actions of the Chinese government and army against their peoples.

Having been in Beijing on June 4th, 1989, I was regularly invited thereafter to lecture about what had happened and why. The task was both painful and difficult: painful, because of the deaths, misery, sorrow, and fear that had to be narrated, and the uncertainty surrounding what had actually happened; and difficult, because the standard Western media had given such a misleading picture of the Chinese scene that the full extent of the many tragedies unfolding there were—and remain—largely unknown.

With few exceptions, media coverage of China, supported all too regularly by "expert" China watchers, basically reflects the concerns of large corporations and the United States government, with the mischievous consequence of rendering virtually invisible the manifold particulars of Chinese life that do not comport well with American business and foreign policy interests; which in turn renders basic moral issues equally invisible.

This situation has obtained for most of the twentieth century; the government and media have consistently been in near unanimity in telling us how we should see China, often using moral absolutes to make the picture(s) clear. For a

decade beginning in the late 1920s, Chiang Kai-shek's Guo-mindang was portrayed as a fledgling democratic move-ment. The Generalissimo was struggling against warlordism in an effort to re-unify the country, and make it a capitalist democracy, Western style. The Guomindang's alliances with landlords, and some warlords, and its lack of concern for the peasantry, were not important, because Chiang stood for a China that would prove an unparalleled market for U.S. goods. And the Communist "bandits," as Chiang referred to them, were seen as just that: bandits; the enemy of my friend is my enemy.

With the publication of Edgar Snow's *Red Star over China*[2] the picture began to shift in the other direction. Long-ignored problems with Guomindang rule now come to light, and the Chinese Communist Party, now in Yanan, becomes a better hope for the peoples of China; how could anyone not applaud the heroism and idealism of those who endured the Long March? But in accounting for the impact of that book, we should look less at what it did and didn't record, and look more at the state of world affairs shortly after the book was first published in 1938, the same year the Japanese pro-mulgated a "New Order" for Asia, and a year after they invaded China proper. This "New Order," later designated as "Greater East-Asia Co-Prosperity Sphere," would have denied American industry access to the China market. Hence it had to be opposed. The Communists, now under Mao, opposed (on other grounds) the Japanese. Hence they had to be supported, at least partially, and they were; the enemy of my enemy is my friend.

By the end of the next decade (1949), however, Mao had

grown horns. The Cold War was on in earnest, and Mao appeared to be on the best of terms with Stalin. Hence Mao had to be opposed; the friend of my enemy is my enemy.

The horns shrank again in the early 1970s. The realities of the Sino-Soviet split were no longer denied, and the Cultural Revolution seemed to be bringing progress to China. With Eastern Europe closed off, Western Europe and Japan taking off economically, and U.S. corporations anxious for new markets, China, soon to have a billion potential customers, became a great place again. And it got even better after the twice-disgraced Deng Xiaoping assumed power, and initiated his economic "reforms."

What all of these narratives share is a consistent downplaying, or ignoring, of those concrete Chinese realities at variance with the image that U.S. foreign policy concerns required at the time, and worse, these narratives have not allowed us to entertain the possibility that differing groups and factions in China might have been truly concerned about the welfare of their country, and that they may well have had morally legitimate reasons for opposing the programs and policies of their opponents (i.e., the Guomindang–Communist Party; Mao Zedong–Liu Xiaoqi; Zhao Ziyang–Deng Xiaoping).[3]

Returning to the near-present, a few strong moral judgments were (and are) consistently made about post–Cultural Revolution China and her "Beijing Spring":

1) The free-market economic initiatives undertaken by the government a little over a decade ago brought great benefits to the majority of the Chinese peoples, and these ini-

tiatives are more rational, efficient, and humane than the socialist policies the government had pursued earlier. Morally praiseworthy.

2) Chinese students, imbued with Western democratic principles, and motivated by idealism, demanded that the government take political initiatives to parallel the economic initiatives. Again, morally praiseworthy.

3) Chinese politics are all and always power politics; the horrors of June 4th and afterwards were fundamentally caused by the hard-liners in the Politburo being unwilling to surrender any of their power or prerogatives. Morally blameworthy.

These images, the larger picture that emerges from them, and the attendant moral judgments, are all highly simplistic. What follows is a rather different picture—a mosaic, if you will—one that is more complex politically, socially, and economically, and consequently far more troublesome to judge morally.

But again, my aim is not confined to present an alternative picture of China *simpliciter*. Rather is the book also intended to be a study of issues and problems that must sooner or later confront the citizens of the Western industrial democracies as well, especially in the U.S. Despite a government that consistently misrepresents them, and a commercial media that systematically misleads them, I believe the American peoples, innocent or otherwise, merely wish for the Chinese the achievement of the same material standard of living that is enjoyed, more or less, by a (declining) majority of Americans. But if the alternative picture of China drawn herein is at all accurate, it implies that the Chinese

cannot ever even begin to approach the level of material affluence typical of middle-class America, and it implies something more: that future generations of Americans cannot maintain that level of material affluence either, and that it would be unjust and immoral for them to attempt to do so.

The "American Dream" is, I believe, just that: a dream. It cannot be realized by many more people than are now living it (a fifth of the human race at best), it is currently being realized by that fifth at the expense of the poor peoples of the world (almost three-fifths of the human race), and unless present scientific analyses of the condition of the earth's environments are altogether mistaken, it will not even be possible for the well-off fifth to live materially as they are for much longer, even at the continued expense of the poor.

Although these ideas—and a great many of the facts and figures supporting them which run through these pages— are depressing to contemplate, this book is not a study in pessimism. We must learn more *about* the Chinese, so that we can change the foreign policies of our governments which are hurtful to them, and we must equally learn *from* the Chinese—a humbling thought—so that we can change those domestic policies of our governments which are so hurtful to ourselves.[4]

Hence the title of this work. The more openly and deeply we look through a window into another culture the more it becomes a mirror of our own, and my reflections of and on China are given here in the hope that the American Dream will one day be replaced by a more universal dream, one that can be shared by all peoples, holding their humanity in common.

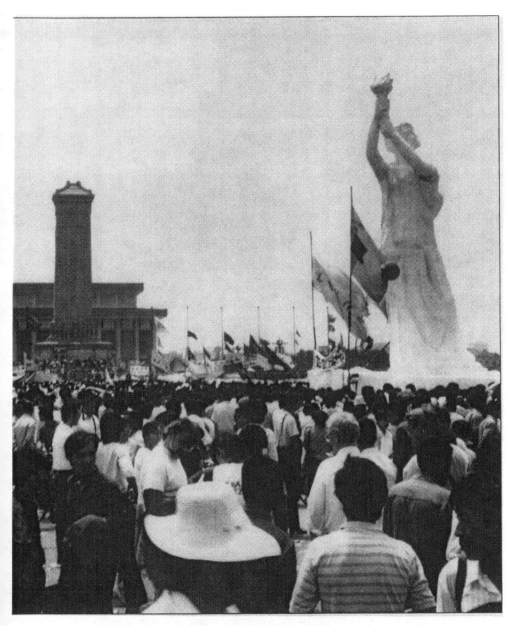

The "Goddess of Democracy" in Tiananmen Square, June 1, 1989.
Photo courtesy of Lisa Scheer.

Free market wares on a Beijing street corner, late May, 1989.
Photo courtesy of Lisa Scheer.

I | Yesterday
(June 4th, 1989)

The standard picture of contemporary China looks roughly as follows: a group of reactionary octogenarians (Deng Xiaoping, Yang Shangkun, Li Peng, plus friends and relatives) is struggling to maintain power at all costs, for the sheer sake of power, after winning a Politburo battle in late May, 1989, against reformist opponents (Zhao Ziyang, Hu Qili, etc.). Idealistic students struggling for political freedom and democracy had triggered the Politburo battle by their marches, demonstrations, and occupation of Tiananmen Square. And the students' actions had been earlier triggered by the rational, semi-capitalist economic reforms instituted shortly after the deaths of Mao Zedong and Zhou Enlai, and the consequent demise of the hated Great Proletarian Cultural Revolution.[1]

The picture had a few minor variants. The *Washington Post* endeavored to blur the portrait of Deng as unrelievedly evil by allowing that he may be senile,[2] (perhaps true), while Harrison Salisbury tried to blur it in another direction by saying that Deng was only following the ancient customs of his imperial ancestors in murdering opponents (a statement as ludicrous as was Salisbury's claim to know China ". . . as well, or better, than any member of the Standing Committee").[3] As for Zhao the reformist, the Newspaper of Record

warned that he was not altogether a liberal democrat.[4] CBS News made it clear during its live coverage of the occupation of the Square that students had no real plans beyond the immediate moment, no program for political change. And ever so slowly and briefly, it was acknowledged that the introduction of market forces into the economy had led to a little corruption, a little inflation.[5]

These and other trivial variations notwithstanding, the overall picture remains fairly stark in black and white: some high government leaders, having seen the wrongheadedness of socialist economic principles, were slowly turning to free-market mechanisms—which were bringing increasing prosperity to most Chinese—and they were supported in these efforts by idealistic young students who wished to extend those capitalist principles into politics, until other government leaders, reactionaries, put a stop to progress simply because they were afraid of losing their power.

Lest this brief account of the standard picture be taken as caricature, consider the following, from a diatribe by the sinologist/journalist Jonathan Mirsky:

> Deng Xiaoping and his elderly colleagues . . . were prepared to do anything—literally anything—to ensure that the rabble [sic] in the square and their covert supporters at home and abroad did not succeed in forcing the resignation of reliable Party loyalists . . .

He later continues:

> The 27th and 38th Armies did not enter the square to clear it. They were sent to punish—and to ensure that never again would the army allow itself to be stopped by nonviolent means or to exhibit sympathy with the demands of the demonstrators.

If anyone still doubts that the spirit of Fu Manchu is alive and well in Zhongnanhai, Mirsky has more to say:

It is plain that Deng, Yang Shangkun, and Li Peng wanted the demonstrators and their supporters in China and abroad to be taught a lesson from the violent crackdown.

(In the *New York Review* article from which these quotes were taken, Mirsky regularly provides footnotes and documentation for a number of points which are either well-known, obvious, or inconsequential. For the quoted statements, however, no evidence whatsoever is proffered, leaving readers to wonder how Mirsky was able to penetrate the minds of Politburo members so clearly).[6]

Statements similar to Mirsky's can be cited ad nauseam, but the overall picture of current China as drawn by the U.S. media is clear enough. It is a mischievous picture. First, it is cynical, and it reinforces the old racist stereotype of China as an "Oriental despotism"[7] by portraying all Chinese politics simply as power struggles, lacking genuine inter-governmental moral dimensions. It also wrongly suggests that the Tiananmen story may have ended well if only the minimal student demands had been met, and further, it provides precious little insight into the quality and quantity of problems any Chinese government must face, problems long resistant to principled solutions without moral compromises.

To be sure, the picture painted by the Chinese government is no less starkly black and white, and is equally misleading. In his official report to the Standing Committee of the Seventh National People's Congress on June 30th, 1989, Beijing mayor Chen Xitong described the tragic events as having been caused by a mere handful of "black hands"—thugs and counter-revolutionaries—who had managed to agitate the workers and mislead the students, in an effort to bring chaos to the country. (Why they wished to do this was

not explained.) After an extended period of attempting to calm the city by peaceful means, the government was finally obliged to call in the brave, resourceful, and caring troops of the People's Liberation Army to clear the streets and the Square, and to restore order in the city.[8]

To reject the Chinese picture for the caricature it is, does not, however, oblige us to accept the American caricature. There is an alternative picture, with little that is black and white, much that is gray. It does not provide much justification for either the foreign policy of the U.S. government, or the domestic policies of the Chinese, and it provides no justification whatsoever for the killing and subsequent executions and repression in Beijing and elsewhere in China. Unfortunately, the alternative picture is also not greatly encouraging to those seeking a humane, environmentally sound democratic state either, for the issues and difficulties facing China at present are so complex, intractable, and morally conflicting as to make the pressing problems of Central Europe—or even U.S.-ravaged Nicaragua, El Salvador, and Iraq—pale by comparison.

To begin the sketch of the alternative picture on some personal notes, I returned to China in late May of 1989 to observe the changes that had taken place in the five years since I had lived and worked there, from 1982 to 1984. Even before the tanks crushed into the Square I did not like much of what I saw. Traveling over 50,000 kilometers in China earlier I had encountered a total of three beggars: an unbalanced eccentric in the outskirts of Shanghai asking for grain coupons, and two destitute families on a sidewalk in Taiyuan, with a small paper in front of them containing a written plea for small change. Five years later, however, I

saw on average more than a dozen beggars a day in Beijing, most of them young peasant women with small babies in their arms. Near the Great Wall, an elderly farmer approached me, hunched over not only from his life of labor, but also apologetically, even though all he wanted was the empty aluminum can I was holding.[9]

Pawn shops, always associated with poverty, were all closed in China after Liberation. They have returned. Even by American standards the interest rates are high: 1 to 2 percent per month on credit cards in the U.S., but 9 to 15 percent in the pawn shops of China.[10]

In the Autumn of 1983, the government mounted a short-lived campaign against "spiritual pollution," complaining, among other things, about the pornography that was supposedly inundating the country. Neither I, nor anyone else I knew, however, were able to find any, even after attempting specifically to do so.[11] I found it in abundance in 1989, with cover photos—of Chinese, not foreigners—that even the dregs of the U.S. slicks confine to their inside pages.

The porn medium of choice, however, seems to be videotapes. Most households in Shanghai had television sets in the early 1980s but not VCRs, which are recent arrivals; by 1988 Shanghai had 22 video publishers, over 40 retail stores, and 470 screening establishments. Porn movies followed close behind, with the municipal authorities confiscating over 15,000 porn videos during the first nine months of the year.[12] Whether or not there are any "stars" in this medium yet I was unable to ascertain.

There are also other opportunities for young women to get ahead in contemporary China (almost all major leaders, officials, and entrepreneurs are men), especially if they are

young and attractive. It was common knowledge in Beijing in 1989 that if anyone wanted a woman, there were many to choose from; it was not common knowledge before. Surely there must have been at least a few Chinese prostitutes in 1982, in Shanghai, where I lived, if nowhere else; but again, neither I nor anyone else I knew ever saw or knew any, or were solicited by them. Since June 4th the government proclaimed a crackdown on prostitution, and has claimed success. But I suspect that most of whatever success has really been achieved can be attributed largely to the great decline in tourism the past two years.

These examples are not isolated curiosities, nor are they difficult to learn about. Even the *China Daily* and the *Beijing Review*, which operate on the sufferance of the government and are not noted for their investigative journalism, provide an abundance of evidence for the social decline that has accompanied the economic policies begun in 1978. To take just a few captions, virtually at random: "Traffic Police May Be Given Weapons," "Forests Plundered Despite NPC Laws," "Corruption Net Catches 162 Official Offenders," "Beijing to Send More Laborers Abroad," "Shanghai Bar Girls Pour into Japan," "Efforts Urged to Fight Smuggling."[13]

Even more grotesque is the recent rise in organ transplants by hospitals in China for outside cash customers, especially from Hong Kong. A letter was sent to all doctors there offering kidney transplants at the Eastern China Military Region Main Hospital in Nanjing for U.S. $12,800, which included round-trip air travel. There are two possible sources for the kidneys: 1) hospitals are removing them from executed criminals and/or dying patients in order to

obtain badly needed hard currency (from overseas Chinese) for medicines and equipment; and/or 2) desperately poor people are selling their vital organs to whomever will buy them.[14]

Babies (especially sound females) are also for sale in China to adoptive Western parents. A gray market has recently been developing between American couples who wish to adopt a Chinese baby, and the orphanages which are taking in an increasing number of infants who are being brought to major urban areas, and abandoned there. The going price for a baby ranges from three to five thousand U.S. dollars, which the orphanages claim they must charge in order to secure the monies necessary to take care of the physically and mentally disabled babies brought to them, babies unwanted by anyone else inside or outside the country, and whom the government cannot provide the funds to care for adequately.[15]

All of these considerations suggest that perhaps a fair number of Chinese, especially the elderly, give a different meaning to the expression "bourgeois liberalism" than most Americans do. Perhaps they believe, want very much to believe, for example, that their government is as opposed to their granddaughters becoming hookers, porn stars, and/or drug addicts as they are. Again from the *China Daily*:

> The amount of drugs confiscated in the first quarter of 1991 was double the amount for the same period in 1990.[16]

In cataloging these social horrors in this way I am not implying that capitalist economic policies caused them directly, that they are a necessary concomitant to free-market endeavors. It is logically possible to have a thoroughgoing

capitalist economy without prostitution, pornography, usury, violent crime, smuggling, organ or baby selling, or drug trafficking. And perhaps a great number of Chinese women—and men—might have been willing to sell their bodies, or parts of them, during the famines of the Great Leap Forward period from 1958 to 1961.[17]

But during that period, and continuing through the early 1980s, the grinding poverty and hunger were fairly evenly distributed in accordance with socialist principles. Some cadres no doubt abused their position to coerce favors they sought, but for the most part selling could not take place because there were no buyers; whole communes, counties, and even provinces suffered, but within them people suffered about equally, and the cities weren't accessible (a point to which I will return below). Now, however, there are great disparities of wealth in China, which gives poor young women the freedom and opportunity to sell themselves, or parts of themselves, or their babies, to the highest bidder.

To all of this a cynic might respond that I am being too sentimental, and imposing my values on others: the recent scandals about the widespread selling of women in China, for instance, a custom millennia old, shows that family bonds, at least as they pertain to young females, are not seen and felt in China as they are in the West. The scandal is indeed a major one (at least 100,000 cases in the last few years), and the government has made it one of the six targets in its latest "anti" campaign.[18] But when we look at the areas where the practice has developed, we find, coincidentally, areas of the most grinding poverty in the country. I can appreciate arguments for moral relativism as well as the

next person, but it is extremely difficult—or racist—to believe that material deprivation does not have to be stark for such practices to occur, and that mothers, fathers, grandparents, and siblings do not grieve mightily when they engage in the practice, and for a long time thereafter. (Surely we must acknowledge the other as other, but if they become *wholly* other, they become depersonalized. I suspect that the American peoples would have indulged in far less flag-waving during Operation Desert Storm if, instead of merely watching Nintendo-like fireworks raining down on Baghdad, they were shown as well the faces of Iraqi grandmothers mourning the victims of those "fireworks.")

To anyone with a minimal knowledge of the history of capitalism my observations of changes in China will come as no surprise, just as it is not surprising that the U.S. capitalist media have largely ignored these elements of the economic "reforms."

They have ignored much more. The idealism and courage of the demonstrating students were widely, and rightly, broadcast; their personal stakes in the demonstrations were not. Most college and university graduates continue to be assigned jobs by the state. A number of these jobs are boring and/or superfluous, and underutilize the knowledge and skills the students have acquired. Many of these jobs, being state jobs, pay wretched wages: a beginning college instructor, for example, earns about half the wages of a cab driver. Worse, a great many students attending urban universities come from rural areas, and are regularly asked to return there after graduation, particularly to work as middle-school teachers. Life in the countryside is still primitive both

culturally and economically compared to the cities, and consequently a large number of these students seek to remain where they have studied.

All of these are legitimate personal concerns, but it is not at all clear what the government should have done about them. If all university graduates were free to live wherever they chose, the major Chinese cities would soon collapse under their weight; virtually all of them are already horribly overcrowded. And it is admitted on all sides that these cities cannot even productively engage all of the intellectuals currently living in them. Still more troubling: if all, or most, of the best and the brightest in China—educated at state expense—do not wish to return to the countryside, who will teach the more than 700 million peasants who live there now, and whose descendants will continue to live there far into the indefinite future?

The situation of the students is further complicated by their relations, or lack of them, with workers. The young women and men who took the reinstated entrance examinations for university admission in 1977 and 1978 were a special group. They had spent years working in communes, factories, and serving in the army during the Cultural Revolution, and I had the privilege of teaching some of them as graduate students. Their "lost" years deeply sensitized them to the drabness and poverty characteristic of the lives of most Chinese. Not overly enamored of the Party, these young people were nevertheless committed to working for the development of a humane Chinese socialism. (Many of these people are currently in the U.S., with Ph.D.'s in or near to hand; after the events of 1989, when they will return to their homeland is anyone's guess.)[19]

But these students were indeed a special group. I met several others older and younger who were similar in outlook, and a number of faculty as well. But in general, Chinese students and intellectuals are fairly antipathetic to workers and peasants, just like the vast majority of their American counterparts. During the student demonstrations of December 1986, the workers were kept at a distance, as they were for the first four of the six weeks of demonstrations in 1989. Even Merle Goldman, strongly supportive of the students and intellectuals, said in a *New York Review* article:

> In earlier demonstrations during 1986 and 1987, students had not allowed workers to join the protests and, at the beginning of the spring 1989 demonstration, the students had physically locked arms to bar them from taking part. In both cases the students believed that participation of the workers would make repression by the government more likely; they believed as well that workers would be joining the demonstrations mostly for material reasons and could not be counted on as allies in the struggle for democracy.[20]

The students were correct in assuming that there was less to fear from the government if they kept their distance from the workers.

Intellectuals in general have been fairly constant targets for repression ever since Liberation, and the lives of most of them have been hard.[21] The Party has long distrusted intellectuals, evidenced not only in the campaigns against them, but in the Party's own makeup. According to one study, as recently as 1985 only 4 percent of the 42 million Party members had received a tertiary education, and an incredible 10 percent were illiterate.[22]

At the same time, intellectuals have long enjoyed a sta-

tus in China unknown in any other culture. In traditional
China, for example, intellectuals who had passed the exami-
nations were exempted from certain forms of criminal pun-
ishment. This tradition has continued since Liberation: while
many have been persecuted terribly by the government, few
have been executed.

This pattern was also clear in June, 1989. Probably what
triggered the final decision to send the troops into the
Square was not the students, for the vast majority of them
had already left, leaving only rump groups as consorts to
the goddess, hoping by their symbolic act to stir into action
the delegates to the National People's Congress that was
scheduled to meet on June 20th. On Wednesday, May 31st,
however, three men instrumental in forming the new
Beijing Workers' Autonomous Federation were arrested, and
shortly thereafter crowds of workers began gathering in
front of the Public Security Bureau, adjacent to the Square,
demanding the release of their comrades. Less than forty-
eight hours later, the tanks began to roll in. By all non-ideo-
logical estimates, at least eight times as many workers and
civilians were killed as students in the bloody aftermath. At
least forty-two workers have been executed since, according
to the Chinese press; no student executions have been
reported. "We are nothing but mosquitoes to the govern-
ment," a worker said to me bitterly, slapping his right hand
against his left forearm for emphasis.[23]

This pattern of discrimination has continued. The
Chinese government was preparing to try the "black hands"
they had held in custody for over a year just at the time the
U.S. government was pressuring the Chinese to abstain on
the U.N. resolutions against Iraq, leading many people to

fear that the Politburo had insisted as a quid pro quo that the U.S. remain silent as draconian measures were taken against the dissidents in Beijing. In a basic sense, some of the measures taken were indeed severe: one person was sentenced to thirteen years in prison, another seven, merely for engaging in activities fully protected by the Chinese constitution.[24] Eleven others were given one- to four-year sentences, less time already spent in custody. But two persons were acquitted, and the charges against the remaining twenty-one were dropped at the last minute.[25] Thus, while the penalties were severe, they were nowhere near as harsh as had been feared. All of these people, however, are intellectuals of one sort or another; a large number of workers still languish in prison, in appalling conditions.

The workers were no less unhappy than the students in the Square, but the two groups were basically unhappy about different things. In addition to wages proportional to their services (i.e., higher than worker's wages), young Chinese intellectuals wanted freedom to live and work where they chose, and freedom from the endless papers, permits, and interference in their private affairs insisted upon by mindless petty bureaucrats. (There is, of course, nothing wrong with being self-interested at times, students no less than anyone else. But as the Goldman quote above demonstrates, the excuse given by the students for not letting workers participate in the demonstrations was that the latter were "self-interested.") Workers, on the other hand, wanted freedom from a murderous inflation, and from the increasing threats to their job security stemming from the search for profits under the "individual responsibility" system that underlies the economic reforms.

Just about everything the average Chinese would wish to purchase tripled or quadrupled in the five years since I had left the country, but for most people, wages were about the same. Pieces of fruit that used to cost 15 Chinese cents now cost 50 to 60 cents; the price of a well-made bicycle has jumped from 180 to 650 *yuan*; a bowl of boiled dumplings washed down with a bottle of local beer at a sidewalk eatery cost less than 2 *yuan* before, over 5 *yuan* now. (How much is 5 *yuan*? For most state employees, and many others, it is a full day's pay; fairly expensive for a light lunch.) And thanks to the continued devaluation of the Chinese currency, coupled with the black market demand for foreign exchange certificates, a Chinese worker must now pay well over 1,000 *yuan* to purchase a $100 foreign item that would have only cost 200 *yuan* five years ago.[26]

Thus, in order to maintain even a minimal standard of urban family living, most workers and their spouses must take on a second, and in a few cases a third job. Some people have taken the entrepreneurial road to prosperity. There were a great many more small and mid-level merchants in Beijing in 1989 than there were in 1984, and I was thunderstruck to learn that many of them earn 100 to 800 *yuan* profit per week selling their wares—i.e. anywhere from three to thirty times as much money as the average government employee makes without bonuses, or moonlighting.

Exorbitant though these entrepreneurial profits may appear, they are relatively small when compared to those available to a properly placed and well-connected Party or government official, thanks in large measure to the multi-pricing policies the government has only recently abandoned. Tens of millions of *yuan* in illegal profits have been

taken by corrupt bureaucrats (few of whom have been pros-
ecuted), bleeding the productive sectors of the economy, and
shrinking the monies available for the provision of social
services.[27]

Almost without exception, the beggars I encountered in
May, 1989, were peasants—obvious from their dress, de-
meanor, and dialect—indicating that all was not well with
the economic reforms in the countryside either. The Chinese
press regularly reports a peasant opening a factory here,
another buying a truck there, but a more telling story
appeared in December, when the government reported that
the average *annual* income of China's more than 700 million
peasants in 1988 was 500 *yuan*, about U.S. $110.[28] For com-
parison, this is approximately one-fifth of the average
annual income of Honduras—which is itself a long way
from being an economic Eden.

Another sign of the rural times is contained in a research
report describing the investigations of sociologist Gail
Henderson:

> Her thesis is that although economic reforms have resulted in a
> marked rise in investment in health resources, inequality in access
> to services has also risen (particularly as rural residents lost insur-
> ance programs) and that provision of certain preventive services,
> previously related to improved health status, has been under-
> mined by the decollectivization of rural health care.[29]

Against this overall background, it should be clear that
the Politburo conflicts preceding June 4th, continuing in at-
tenuated form even now, cannot be explained away merely
as a to-the-death struggle for wealth and power between the
hard-line geriatric set and their ostensibly more open-
minded opponents. Basic moral principles were involved.

All members of the Politburo, and the Central Committee as well, have a fair amount of power, and—given the age of most of them—probably all the wealth they can consume. If all they worry about is their own authoritarian power, why are they so concerned about their successors? What difference does it make?

We must remember that many of the top leaders, and some nowhere near the top, are not merely old, they are old *revolutionaries*. Although their ranks are thinning rapidly, many of them are veterans of eight years of deadly war against the Japanese, followed by four years of civil war against the Guomindang. The moral ideals that motivated these people have surely been dimmed and corrupted after forty-two years of governing, but it would be at best mistaken, at worst malicious, to suggest that those ideals never existed, or had disappeared altogether.

Appreciating that a large number of fundamental moral issues could be at stake, the Politburo conflicts of 1989 can be seen in a new light. At the surface level, all sides to the disputes—students, workers, Party factions, etc.—had to be deeply troubled by the nature, pace, and direction of the economic "reforms" as they had been put into practice since the early 1980s. Some people were troubled most by corruption, others by inflation, still others by ongoing bureaucratic meddling and incompetence; and probably everyone had at least some misgivings about the increasingly obvious rising disparities in standards of living, coupled with the rise in crime, drug trafficking, prostitution, pornography, homelessness, begging, and rural poverty. All the indications, in short, that bespeak human degradation and the breakdown of cultural values.

Similarly, the several parties to the disputes agreed—as the students regularly reiterated during their occupation of the Square—that whatever changes had to be made, they had to be undertaken by the Party, because the only probable alternative was civil war, with the possibility of a return to the warlord regionalism that plagued the imperialist-dominated country for the century between the Taiping Rebellion and Liberation.

Disagreements thus arose not over whether to make changes, but which changes to make, and how to effect them. It appears that the Zhao Ziyang group wanted to prosecute corruption more vigorously, as the students were demanding. Further, by acknowledging the student movement as patriotic, this group could gamble that the idealism they were simultaneously acknowledging would outweigh the students' more self-interested concerns. And they could equally gamble that by extending freedom of the press and of assembly, they would have extra-governmental mechanisms to more fully expose corruption, price-gouging, exploitation, poverty, and greed, with hoped-for results of an increasingly equitable raising of living standards, a lowering of inflation, more productive investment, and an overall improvement in the quality of Chinese life. A result, in other words, in keeping with the moral ideals of a humane Chinese socialism.

At one level this was a reasonable and principled position, but at the same level there was an equally reasonable and principled reply: what if the gambles lost? Granting the patriotism, moral idealism, and bravery of the demonstrators, all of them (workers and students) nevertheless had a strong economic self-interest in the matter, and given their

relatively advantageous position, there had to be a distinct possibility that the extant untoward situation might simply worsen, leading to a different result: an acceleration of the trend, already clearly visible, of a return to the China of old, with a securely entrenched wealthy minority living well at the expense of a very large, impoverished, and degraded majority—with an enfeebled Party and government increasingly incapable of reversing the trend. A result, in other words, not at all in keeping with the moral ideals of a humane Chinese socialism.

The debate was brutally terminated late in the evening of June 3rd. Deng and Li had made a number of saber-rattling pronouncements earlier, hoping perhaps to verbally coerce the students and workers into abandoning their demonstrations. It is arguable that the Party did not anticipate the violence that ensued: at least twice in the past, at the death of Zhou Enlai in 1976, and during the student demonstrations a decade later, large crowds gathered for several days in defiance of government orders, but stopped when physical force was threatened.[30] In any case the ferocity of the demonstrators' response to the army surprised everyone (who shot first at Muxidi and Fuxingmen will probably never be known; few dispute the claim that in the Square, Molotov cocktails were thrown at the A.P.C.'s and tanks before the latter opened fire).[31] Not being able to read Deng's mind like Jonathan Mirsky, I have no idea whether, or to what extent Deng may have regretted calling out the troops when he learned of the resulting carnage; he is as likely to apologize as were the governors of Ohio and Mississippi for the killings at Kent and Jackson state universities in 1970.

In sum, while the crackdown remains altogether oppro-brious, we should otherwise be willing to give the disputing Party groups their due. Power-driven they may have been, and insensitive to the hostility of many people toward the consequences of their policies; but they were also more than that, and much more was at issue than power. Condemning the Politburo for the killings in the Square is not the be-all and end-all of a moral assessment of contemporary China; it is at best a beginning.

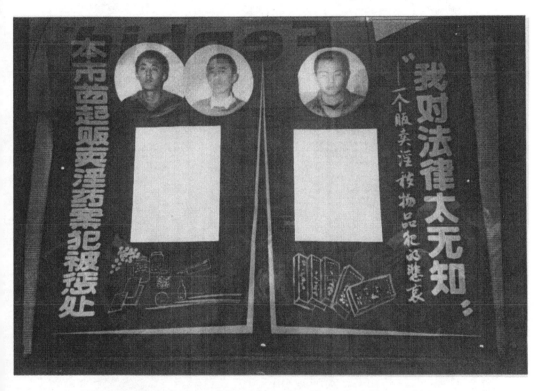

Crime does not pay. Official poster, Shanghai, June, 1991.
Photo courtesy of Lisa Scheer.

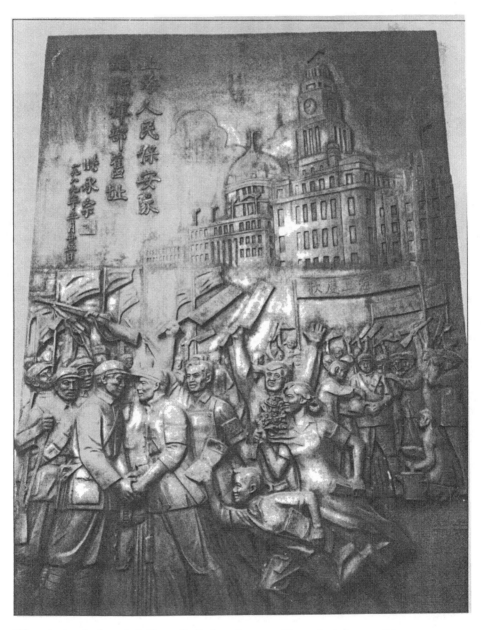

The struggle for socialism. Relief sculpture, Shanghai, June, 1991.
Photo courtesy of Lisa Scheer.

II | Today

Before moving beyond June 4th, we might reflect for a moment on contextualizing it temporally. Sad as everyone had to be about the plight of the workers and students in China, almost everywhere else in the world things looked much brighter. While the tanks were moving into the Square, the Polish people were holding their first elections in over a half-century. The following day the Ayatollah Khomeini died, raising hopes for a more moderate Iran, and reduced tensions throughout the Middle East. Mikhail Gorbachev was continuing the political efforts no one dreamed possible for a Soviet leader, efforts that later won him the Nobel Peace Prize. And by the Autumn, East Germany would disappear, Hungary would overthrow its oppressive governors, a dissident playwright would emerge as the spokesperson for the peoples of Czechoslovakia. By Christmas, even Romania rid itself of its dictator. Communism had failed. The Cold War was won. The American way of life would prevail. The peace dividend was near to hand. Except for China, all looked upbeat, both at home and abroad. Even the invasion of Panama might be seen as the last vestiges of a war mentality on the part of government leaders.

Now, two years later, a darker mood prevails. Lech Walesa has elected to lead Poland away from Socialism, but unemployment is now over 15 percent in the country, inflation is emptying the purses of those who still have a job, and there are few buyers for the state-owned factories up for sale; exactly five out of over eight thousand found buyers in 1990; Serbians, Croats, and Slovenes do not get along in Yugoslavia, nor do the Czechs and Slovaks, except for respecting Vaclav Havel; Hungarians are experiencing repression in a Romania that has the largest number of sick and abandoned children per capita of any country in the world; Russians, Baltic peoples, Armenians, Moldavians, Azerbaijans, and others—many of them anti-semitic—are at each other's throats in the Soviet Union, severely crippling Gorbachev's initiatives. Nothing has gotten better in Central and South America; Nicaragua, for example, currently has an unemployment rate of 40 percent, and inflation is 5000 percent per annum. India is becoming ever more violent. Horrors are rife throughout the Middle East in general, and in Iraq in particular; all of which have dashed any hopes for a peace dividend here at home, while the numbers of homeless continue to increase along with the deficit.[1]

Again, China is an exception of sorts. While it remains a sorry place, conditions don't seem to have deteriorated further since the Beijing Spring. Inflation has not worsened appreciably, workers' lives are not as precarious, relatively speaking, as they are in Central Europe or Latin America, and the widespread fear that the government would be lethal in the trials of the "black hands" after Chinese abstention on the U.N. resolutions against Iraq, has not been realized.[2] In short, hated though they will undoubtedly continue

to be because of their culpability in the events of June, 1989, the governing Politburo has continued to govern, and by comparison to much of the rest of the world, there are fewer immediate portents of massive hardship and unrest.

I do not believe, however, that such observations can provide solace for us as we contemplate the sorry state of world affairs. If the Chinese economy is not right now in the same precarious position as are the economies of many other countries, it soon will be, because right now the country has almost all of the evils of both capitalism and Stalinist forms of socialism, and the benefits of neither.

Seen in this light, it is misguided to see a major distinction between the so-called "liberals" (Zhao Ziyang, Hu Qili, Li Ruihuan, etc.) and the "conservatives" (Deng Xiaoping, Yang Shangkun, Li Peng). At a level of analysis that goes beyond the simple-minded power struggles so beloved by China watchers and the U.S. media,[3] the policies of both groups involved moral compromises that make them equally unattractive to anyone sympathetic to the plight of the Chinese peoples. Both groups are committed to the same kinds of economic reform, yet, as should be clear by now, the introduction of foreign, highly technological market-driven economic factors into a huge and impoverished country with few traditions of self-governance beyond the family and village level will almost surely eventuate in increasing misery and injustice.

In the first place, we must question what "reform" can mean, coming after a revolution. Is the surrendering of the principle of equalitarianism—the mainstay of the government's claim to moral legitimacy—in favor of market-forced gross inequalities a reform, or is it reactionary? The dual

engines driving the "Four Modernizations" are capitalist market relations combined with political authoritarianism, which, to give it a brutal but accurate name, is fascism; however much he might squirm in their company, the current domestic policies of Deng are of a piece with those of Mussolini and Hitler.[4]

Unfortunately for most Chinese, the basic policies of the Zhao group differ only in degree from those of Deng. The "new authoritarianism" advocated by many intellectuals associated with Zhao (who would benefit from it) would replace Deng's "old authoritarianism," but this would only replace a form of fascism with a benevolent (but largely unchecked) despotism, and would continue the capitalist-style industrialization of China, and its further entrance into the international economic order.

As is increasingly the case in the U.S., new jobs being created in China by the joint ventures fall pretty much into two classes; a fairly small number of highly skilled technical and managerial positions requiring university training, and a much larger number of dead-end, boring, "gofer" service positions, many of which do not even require literacy. And just as the distance between the haves and the have-nots is growing in the U.S., so is there every reason to believe that the distance will also grow in China, the only difference being that there will probably be fewer haves, despite the larger population.

In the early 1980s, Chinese leaders were rightly cautious about jumping into the international marketplace with both feet (the Hu Na and T-shirt quota disputes were evidence of this caution); they appreciated that they were not entering a "level playing field," and that factors and decisions over

which they had no control could have serious negative consequences for many sectors of the domestic economy.

As the "reforms" progressed, however, both Deng and Zhao threw caution to the winds, and began making larger bets in a game neither of them—nor any other Chinese leader—can win, and sooner or later the big losers will have to be the Chinese peoples. It is all well and good to convert tens of thousands of acres from rice to cotton crops, subsistence to cash—so long as the price of cotton is high. But in the world market, the price of cotton is not merely contingent upon the quality or quantity of the crop grown in China: it also depends on how much cotton is grown elsewhere, and worse, it depends as well on the whims and gambling instincts of the managers of a few firms at the Merchandise Mart and Wall Street. Arguments about the "discipline of the marketplace" are irrelevant here, for if the gambles don't pay off a few Chapter 11s will be filed, while the members of the affected firms will continue to live pretty much the same private lives they led before, in material comfort; it will be the Chinese peasants who have to eat the cotton. (Or the Guatemalan, Indian, or Ugandan peasants; the principle applies to peoples in all poor agrarian nations.)

My example of cotton would, I suspect, be challenged by many economists, especially those who see the market system as the only one for the whole world, and who believe such a system necessary not only for economic efficiency, but for political liberalization as well.[5] Their challenge would probably take the following form: if the Chinese grow the best cotton, at the lowest rate, and if they secure multinational or other investment funds for state-of-the-art cotton mills, the Chinese will do spendidly in the world

market, to the extent that even the brokers of Wall Street and the Merchandise Mart will take notice.

Such a challenge has an air of initial plausibility about it, but only as we see it as a response to a single country; it is otherwise smoke and mirrors. One need not be an expert in the dismal science to realize that export-led production and multinational-led investment programs cannot work world-wide, for it is logically impossible for all nations to have trade surpluses: for any set x of countries with surpluses, there has to be another set y, larger or smaller, with precisely matched deficits.

Yet trade deficits are crippling to poorer countries in ways that do not affect the richer few—at least in the short run—because it is significantly the monies derived from sur-pluses that are used for infrastructure development and increased public welfare projects, whereas deficits not only deprive the poorer countries of those monies, they require further expenditures for the payment of interest. And inter-est, however legitimate it may appear to the relatively afflu-ent, is a luxury poor countries with huge needs cannot afford, as any economist from Central or South America knows well.

In just the same way, as Pollin and Cockburn have argued,[6] capital being invested in one country can only come about by capital being withdrawn from others. And given that a great many countries are desperately in need of capital, it must follow that the market system must produce at least as many failures as successes. Given the wealth and present productive capacities of the Western capitalist nations and Japan, we can fairly accurately guess who the

winners and losers will be. (King of the Hill is not played on a level playing field.)

We must look more closely at the problem of capital. Since rejecting their Stalinist forms of government, the nations of Central Europe, and the Republics of the Soviet Union, are seeking high influxes of capital to rebuild their decaying economies on a market basis. All of the countries of sub-Saharan Africa are also seeking capital, as are the countries of Central America and South America, plus much of Asia. Now even if we assume that Japan needs no further capital to maintain its economic strength, and that Germany needs no capital to integrate its eastern portion into the western, and assuming as well that the U.S. does not need continuing influxes of capital just to finance its debts, not to mention rebuilding its infrastructure—all of which, of course, are altogether false assumptions—it may still be legitimately asked whether there is, and will be, enough capital in the world to meet the demands that are, and will be, made on it.

My strong suspicion is that there will be nowhere near enough capital at hand, or capable of being accumulated, to go around, which raises the specter of the leaders of all hurting countries—the majority of them—fighting with each other to get a place in line to borrow from the IMF, World Bank, Asian Development Bank, or private firms—at whatever interest rates the "traffic" will bear; freedom of the marketplace with a vengeance. To be sure, the competition between these poor nations can be reduced somewhat on the basis of racism: Africa could simply be written off, for example. And indeed it might be, for as the Nigerian ambassador

to the U.S. pointed out last June, the monies promised to
Poland this fiscal year are in excess of all funds promised to
all of the nations of sub-Saharan Africa put together.[7]

Nor would the situation look much better if the available
capital was lent equitably to those who needed it, because
much of that capital would then be simply dissipated. If five
hundred of Poland's eight thousand state enterprises are
sold into private hands, can the Polish economy really
improve? But by the Polish government's own estimates,
over $70 billion more than the country has altogether is nec-
essary for privatization of Polish industries.[8] (This should
not have come as any surprise to the Polish government, or
to anyone else for that matter. Privatization cannot even
begin to take place on a large scale *within* a former socialist
state, for in those states the state itself "owned" almost all
property, leaving only criminals, high Party officials, and
people with very rich relatives abroad capable of accumulat-
ing enough capital to buy anything larger than a corner
eatery).[9]

Here we may parenthetically take up a political issue
raised earlier. Many people continue to think that a free-
market, capitalist economy will, must, be followed by politi-
cal liberalization. I suspect this notion keeps currency
because it supports the ideology that capitalism is best for
everyone, which makes it more difficult to appreciate the
adverse effects of capitalism everywhere, and especially in
poor countries. And I have this suspicion because there are
too many counterexamples to this claim for it to be taken
seriously be any non-ideologue: Germany, Japan, Italy, and
Hungary in the 1920s through the early 1940s, and the "Four
Dragons" of today: Hong Kong, South Korea, Singapore,

and Taiwan. To reply that the latter countries are now in the process of developing democratic institutions is beside the point. This is a prediction of events that may or may not come to pass—and there are historical reasons for doubting that they will—but more important, such a reply makes the incredible suffering visited on millions of peoples in all of these countries under their fascist or fascist-like governments invisible; what decent government of today could ask its citizens to endure similar suffering, into the foreseeable future?

This same point can be seen in another way. Different economic systems can be defined, at least in part, by the differing incentives they offer for and to the peoples living in those systems. Behaviors are developed—again, at least in part—on the basis of specific economic incentives, and because behavior patterns become deeply ingrained and difficult to alter, it surely cannot follow that changes in the economic system (different incentives) must, of themselves, bring about behavioral changes, even when moral considerations are not taken into account; human beings are fairly complex creatures.

The problems attendant on a need for large amounts of capital can be even better understood by returning our focus to Chinese agriculture. William Hinton[10] has argued forcefully and at length that the increases in agricultural productivity in China during the early and mid-1980s had little to do with the "individual responsibility" system, that the period of increased yields is already past, and that reliance on capital for further agricultural development can only eventuate in disaster.

Crop yields began increasing after the "responsibility"

system was implemented, reaching a record-breaking 400 million long tons in 1984. Hinton does not dispute the figure, but points out that the reforms are not solely, or even largely responsible for the bumper crop. The yield fell to about 370 million long tons for the following year, with no inclement weather to blame, leading Hinton to the conclusion that much grain had been taken out of the collective storage in 1984—it hadn't actually been grown then.

A second reason for increased crop yields, having nothing to do with privatization, was the introduction of hybrid rice. These seeds were not available in China until the early 1980s, and obviously would have significantly increased crop yields under almost any system of agricultural production.

Even more important, according to Hinton, is the fact that rising yields are dependent on large-scale water conservancy projects, but the dams, dikes, and irrigation systems were largely constructed *before* capitalist efforts began, i.e., they were build during the Great Leap Forward and the Cultural Revolution; which raises some troubling questions:

> Can [water conservancy projects] be carried out within the framework of the "responsibility" system? Can funds be raised to pay people to do individually for cash what they once did collectively for work points? In the past people invested their labor on projects that promised future benefit. They reaped the return months or even years later. Now peasants demand payment by the day or by the month. Where will the necessary funds come from?[11]

Where indeed? Yet unless these water conservancy projects and other rural public works are maintained and expanded, it will not be possible for China to feed its population. Only about 11 percent of the country is arable (an area approxi-

mately the size of Ontario) and most of this 11 percent is concentrated in the eastern third of the country, where two-thirds of the population live. Although the government has made many and varied efforts over the years to bring new areas under cultivation, much of the gain has been offset by losses caused by the growth of cities, road construction, and the salinization and erosion of productive soils. Thus Chinese farmers will have to make do with what they have, and under the "individual responsibility" system, some of them may be said to be doing well in the short run, but the present system cannot be maintained, even for those profiting from it.

Hinton[12] writes of the "noodle land" now descriptive of much of rural China, land divided into long private strips so narrow a cart cannot be driven along one's own plot without trespassing on a neighbor's. (This was the last gasp of equalitarianism under Deng: parcelling out the more and the less productive plots of the de-collectivized farms on an equitable basis.) But with such crazy-quilt patterns of land distribution there is no hope of ever mechanizing agricultural production. While the Chinese do not need the heavy combines and other gross machinery characteristic of U.S. agribusiness, they do need *some* mechanization of production, or else the vast majority of China's more than 700 million peasants are doomed to hard, bitter, and impoverished lives. (Again, for these peasants, average per capita income in 1988 was U.S. $110.)

To appreciate the magnitude of this problem, consider the comparison Hinton draws between an average farmer from his native Pennsylvania (not agribusiness) and the average farmer in an *advanced* village in Shandong province: the

Pennsylvanian can till anywhere from 142 to 405 times as much land as his Chinese counterpart, with comparable yields; one day's labor by the Pennsylvanian produces from 213 to 438 times as much as a similar day's labor from the Shandong villager.[13] Under capitalism, how can the necessary number of "walking tractors" and other mechanical aids be obtained to overcome these enormous disparities in labor productivity—and to continue feeding the people?

Because he is an avowed supporter of socialism for China, some people might (mistakenly) take Hinton's figures and analyses as suspect. But he is by no means alone. The Cornell sociologists Victor Nee and Su Sijin say, for example, almost the same things in a recent issue of the *Journal of Asian Studies*:

> In all but one village, cadres emphasized that the collective system was superior when it came to constructing and maintaining public works such as irrigation systems and roads. . . . Many cadres wrung their hands about what they perceived as the state of disrepair of local irrigation systems, power stations, and roads. They worried that without the proper maintenance of these facilities, it would be difficult to sustain continued growth in agricultural production. They observed that the neglect of public works was most serious in poorer villages. Indeed, as we traveled from village to village in the course of our fieldwork, we were struck by the poor maintenance of village facilities. Some cadres wondered whether the current high growth rates could be sustained for long.[14]

Worse, a number of social costs, almost totally unreported by the U.S. media, have also been paid since the introduction of rugged individualism into the Chinese countryside. In addition to the predictable evils of increasing class divisions, gross inequalities in standards of living, and

the exploitation of labor, havoc has been wrought with birth control policies as land-hungry peasants seek more children to help in the fields. Once born the children do indeed go to the fields, evidenced by a steady decline in school attendance in rural areas over the past several years,[15] reversing a thirty-year trend of increasing literacy in the country. For those enterprising peasants fortunate enough to live in areas also inhabited by endangered species, the black market for specimens of these species, dead or alive, is booming. In April of this year six Amur leopard pelts (there are only an estimated forty Amur leopards in the world) were offered for the bargain price of $380 each. Pandas are of course much more well known, and command a higher price: $10,000 for a pelt, $112,000 for a live pair. (The World Wildlife Fund estimates that about three animals from the endangered lists have been killed *every day* for as least the past two years.)[16]

As these accounts of the Chinese countryside suggest, a more general unsavory accompaniment of the "Four Modernizations" has been the continued degradation of the Chinese environment. The country has long been an ecologist's nightmare: in circa 300 B.C.E. the philosopher Mencius noted with sorrow the deforestation of hillsides in a part of North China. But the deterioration deepens with each passing year. Factories continue to be built with few, or no pollution-control devices; most shop floors are as dangerous to work in—they are hot, noisy, have greasy floors, little ventilation, almost no safety equipment—as the coal mines; cities are beginning to experience gridlock from the increasing number of cars and trucks (1990 estimate of slightly over four million),[17] none of which have catalytic converters; ero-

sion is rampant in many areas, salinization in others; the air is foul in many more areas, the water undrinkable everywhere; and the millions of tons of nightsoil placed on the earth annually do little to renew it after millennia of constant cultivation.

Consider water, the conservation of which is the goal of most public works projects. In the aptly titled *The Bad Earth*, Vaclav Smil writes:

> According to a 1979 survey, daily discharges of polluted water amounted to 77.8 million cubic meters or 28.4 billion cubic meters a year (6% of the total volume utilized), with each cubic meter of waste water contaminating an average 14 cubic meters of natural water and the annual economic loss caused by this massive pollution was put at about ¥5 billion. Of 78 monitored rivers, 54 were polluted; 14, including all the major streams, were seriously polluted. . . . Shanghai's situation appears to be even worse [than Beijing's]. The daily discharge of polluted water now surpasses 5 million tons, but only 200,000 tons are treated; and despite the recent substantial increases in waste-water treatment capacity, the city is worse off than it was in the mid-1970s because in the same period new sources of polluted water have added nearly twice as much waste volume.[18]

And lest it be thought that things have been improving since Smil compiled his figures, re-read the estimate above of annual economic loss due to polluted water in 1979: ¥5 billion; for 1990 the figure is ¥70 billion.[19]

In contemplating the enormity of China's environmental problems it is difficult not to despair. Certainly there are numerous environmental problems in the Western industrial democracies too, and they are growing; correcting them is going to require fundamental changes in living patterns. But much can be done that would not drastically reduce material well-being in Europe and the U.S., whereas the Chinese

problems are far more severe, and the level of well-being in China is already so low that any reduction could bring it to the vanishing point.

But if capitalist incentives, and marketization, cannot solve the problems of China's countryside, and if massive industrialization, capitalist or otherwise, is not a long-term option either, what can be hoped for with respect to China? Clearly there are no easy answers to this question, nor any that do not have great human consequences. Before even attempting to answer it then, we must first address a number of other issues, which may help to clarify the moral criteria by which putative answers can be assessed. Perhaps the effort will assist us in better understanding not only the dilemmas of the Chinese, but many of our own as well.

Mao Zedong organized the peasants. The Chinese Communist Party claiming to be a worker's party was a façade from its inception, for there were very few industrial workers in China in the 1920s, and fewer still after the havoc wrought on them by Chiang K'ai-shek's armies, especially in Shanghai in 1927. These peasants fought for Mao in order to realize the modest dreams of every Chinese from at least a millennium before the time of Confucius: a little land, a family, good weddings for one's children, grandchildren, peace and security in old age, a decent burial.

The fundamental moral principle linking these dreams to Mao's early organization efforts, and the organization of the Great Leap Forward and Cultural Revolution, was of sufficient simplicity that even the unlettered could comprehend it: no one deserves a second bowl of rice until everyone has had a first. If is difficult to quarrel with this principle, even for those of us inheriting a moral tradition which stresses

individual freedom and autonomy and which tends to define justice in procedural rather than resultative terms. But cruel realities in China made a mockery, if not of the principle itself, then surely of its attempted realization. The histories of the Great Leap and Cultural Revolution periods are horrible to read and hear, even after discounting the sinophobic and/or rabidly anti-communist reports. The losses were not merely—nor, in the case of the Cultural Revolution, even mainly—economic; far too much physical, psychological, and psychic death and suffering were visited on the Chinese peoples during these campaigns for them to retain moral credibility.

Clearly the attempts to implement on a sustained level the "one for all, all for one" idea ended in disaster as implemented by the Party. But so did the efforts made during the earlier Guomindang period on the basis of "every man for himself." And Deng's revival of the latter idea under the label of an "individual responsibility" system clearly portends disaster again.[20]

The root question here is by no means unique to China, except perhaps in its intensity; it must be faced by everyone struggling to achieve a truly decent society: how obtain a proper moral balance between the just claims of the present day and the future ideal for which the struggle goes on? Economically, even if Western influences, material and otherwise, all but disappeared in China (perhaps they should), every morally conscious Chinese would have to ask whether the increase in material goods accompanying increased productivity would, or would not be canceled out by increased unemployment, decreased job security, and consequent decreased human dignity. By skimping on anti-pollution and

worker safety devices, you can build four factories instead
of three; wonderful for current employment opportunities,
deadly for the workers, the environment, and the genera-
tions who will inherit it. High technology innovations can
make life easier for some, at least in the short run, but lead
to socio-economic stratification, which tends to perpetuate
itself, and to possible other untoward social and cultural
consequences as yet unknown.

Identical issues are confronted in the political realm.
Enforcing the "one family-one child" policy by physical
threat and/or coercive economic sanctions is anti-demo-
cratic and morally dubious; yet there is not a dissenting
voice to the claim that China would be twice as livable with
half its population—which hasn't even leveled off yet. It is a
basic affront to freedom not to be able to move to a city
within one's own country, but granting that freedom would
quickly give China twenty Mexico Citys, and the major
urban areas are already bursting at the seams; depressing
slums are growing up in a number of cities where none were
before.[21] Allowing peasants to grow as many vegetables as
they wish, instead of grains, enriches some of them, and
increases the vegetable consumption in the cities. It also
resulted in the country becoming a net importer of grain
again in 1988—after being a net exporter for four years—and
requires the government to continue heavily subsidizing
grain purchases to prevent hunger riots, with monies the
government does not have.[22]

To all of these concerns it is tempting to reply that people
must of course make sacrifices to achieve a truly just society,
but respect for flesh-and-blood human beings requires that
they be asked and not coerced into making those sacrifices;

to do otherwise is to mistake the disease for the cure, and is ultimately morally indefensible. The world would be a far better place for everyone if all political leaders subscribed to this view, and in principle, it is correct. But it glosses over concrete realities. As Socrates argued in the *Republic*, a just society should be built from the ground up, which is probably why there aren't any, because there are no foundationless societies to begin with.[23] All societies are ongoing, which means that at any particular time, some people have more wealth, more power over others, and control over their own lives than other members of that society. Right now, some people in China have a great deal of power and/or wealth, others have none of either. Who will be asked to make the sacrifices? Who will do the asking? We can be specific: which peasants in near-famine areas of China will be asked *not* to move to a relatively prosperous city? Where are the historical precedents for suggesting answers to such questions, Chinese or otherwise?

Most of these issues, of course, are not unknown to any sensitive person who has reflected on the causes of and cures for social and economic injustice. That they are seldom considered in a Chinese context says much about the distorted pictures of China portrayed by the U.S. media and professional China watchers, making it difficult for us to understand the conditions of the Chinese peoples, and thereby making it equally difficult to appreciate the true conditions in which we ourselves live.

Against this background of problems and dilemmas, a number of ideas come into clearer focus. The first is that when we have to make genuine moral choices, we are sel-

dom able to promote the good; the most that we can hope to accomplish is to mitigate evil (which should also be clear to anyone who has seriously meditated on such issues as abortion, euthanasia, etc.). A corollary of this idea—which I will take up in detail in the concluding section—is that if evil there is to be, then the people who will suffer it should be the ones responsible for choosing the form it takes.

A second idea is that if "standard of living" is measured strictly in quantitative terms of material affluence, than we surely cannot hope for the Chinese to ever enjoy the standard of living currently obtaining among middle-class Americans, for it is not now, and never will be, possible for them to do so. This prediction should be straightforwardly seen from all that has already been discussed, but it can be reinforced by looking at, for example, energy consumption. Americans collectively presently consume a little more than 40 percent of the world's energy, and the average Chinese consumes about 7 percent of what the average individual American consumes. Suppose the average Chinese—over 1 billion of them—came up to consuming one-fifth of the energy the average American uses, i.e., a three-fold increase for them: now calculate the rate of increase of pollutants in the atmosphere from the coal-fired generators of that energy.[24] If we add the additional premise that all nations are now more or less involved in a world economy, we arrive at a conclusion painful to contemplate: much of the material affluence in the U.S. is purchased at the *expense* of poor countries like China. If a Chinese worker in a textile mill earned even roughly the wages of her American counterpart—necessary if she is ever to dream of owning, say, an

automobile—what would be the cost of a Chinese T-shirt in the U.S.? (The point is again general. We can substitute "El Salvador" for "China," and "coffee" for "T-shirt.")

This same idea can also be seen from another direction, and from a different part of the world. In a recent book, Hisahiko Okazaki, Japan's ambassador to Thailand, wrote the following:

> In Southeast Asia today, prawns are packed at great expense, frozen live lest their claws be damaged before arrival in Japan. Substandard claws are thrown out. A Japanese is likely to think he is contributing to [the] modernization [of a developing nation] when he imparts knowledge of quality-control techniques.
>
> That may be so. But how can one assuage the jealousy and resentment of a hungry man as he watches prawns being packed in this way. And how would such a person feel if he knew that the cost of one person's meal at the wedding where the prawns are to be served comes to more than his monthly salary?[25]

If these considerations have merit, they suggest strongly that if we wish for the Chinese a higher standard of living, then the standard must have a significant qualitative dimension. But even if my arguments are wrong-headed this point should stand, as can be seen by looking at the U.S. Per capita income, consumption of newsprint (printed paper), and caloric intake are regularly taken as indices of a country's standard of living. Up to a point, they are useful figures; an average annual income of U.S. $100 means extreme poverty under any circumstances, low paper consumption bespeaks widespread illiteracy, and an average daily intake of less than 1,000 calories shows large-scale hunger and malnutrition. But the converse does not hold; more is not always better. Many Americans with very high incomes lead wretched lives, by their own lights; much of our printed

matter comes in the millions of pieces of junk mail distributed daily; and many of the calories we consume come to rest permanently in and on our stomachs and backsides.

It must also be said, following Amartya Sen,[26] that such easily quantifiable items as income and savings have only instrumental, and not intrinsic worth; we want them not for ourselves, but as the means whereby we endeavor to live meaningful lives. Savings, in and of themselves, do nothing for us; but they can, for example, provide security, and security is, in general, a good. If, however, such matters as health care, education, pensions, services for the elderly, and so forth, are provided by the community in which one lives, then one can lead a highly secure life with relatively little savings (such services were provided by the extended family and clan system in imperial China, albeit imperfectly).

To insist upon a strong qualitative dimension to determine a decent standard of living requires bringing in value judgments, and it is a commonplace—a vulgar commonplace—that values are subjective, private. The political, legal, and moral systems of the Western capitalist democracies are all predicated on the view that the good cannot be objectively determined for everyone, so that the basic task of the modern state is to create and maintain institutions such that each individual, subject to certain constraints, is free to pursue her or his own definition of the good in both the economic and political marketplaces. When, therefore, I maintain that we must make value judgments about standards of living before we can know what to hope for for the Chinese, it must appear that I am insisting that my own, or in a vaguer sense, American values should be applicable to the Chinese. As a consequence, if the hopes I believe all people

of good will should have for the Chinese, and the arguments
on which those hopes are based, are to have any purchase,
we must first explore this concept of the privately evaluating
individual as that concept has been developed in the mod-
ern Western philosophical tradition, and then contrast it
briefly with the concept of what it is to be a human being
that defined Chinese civilization for well over two millennia.

Village scene, Shanxi province, at straw-gathering time, June, 1991.
Photo courtesy of Lisa Scheer.

A Chinese grandmother in rural Shanxi province, June, 1991.
Photo courtesy of Lisa Scheer.

III | Interlude: Modern Western and Ancient Chinese Concepts of the Person

It is a very basic assumption of our moral, social, and political thinking that human beings have rights. As citizens of the Western capitalist democracies we are strongly inclined to insist that certain basic rights obtain independently of sex, age, color, ethnicity, abilities, time or place; we have certain rights solely in virtue of being human.[1]

This basic assumption is embedded in a larger conceptual framework in which the essence of human beings lies in their individuality, their autonomy, and their rationality. To be sure, within this larger conceptual framework—the Enlightenment model—a variety of moral, economic, and political theories have been advanced, not all of them compatible with each or any of the others. Nevertheless, the concept of human beings as rational, autonomous, rights-bearing individuals is never far from center stage in our moral, economic, and political considerations.

In the international arena, today, as on most days, a number of our fellow human beings are confined in highly inhospitable environments, are in fear for their lives, and are being subjected to a host of physical and psychological in-

dignities. Some are being incarcerated and/or being tortured because of their color (e.g., blacks in South Africa), others because of their ethnicity (e.g., Kurds in Iran, Turkey, and Iraq), still others for their political beliefs (e.g., much of the world, including China), and still others are being persecuted in similar ways because of their religious and attendant social convictions (e.g., Baha'is and others in Iran and elsewhere). We are angry at these circumstances and events, indignant that they continue to occur and regularly feel frustrated that we are personally able to do so little to halt such heinous practices. How would we describe our feelings and beliefs about them? They are unjust, we would say. No one should be imprisoned, tortured, or held hostage simply due to their color, ethnicity, political or religious beliefs, because all human beings have basic rights, rights which are clearly being violated in these instances. When, having broken no reasonable law, individuals are denied their liberty, their livelihood, their property, and are in fear for their physical well being, they are being unjustly deprived of the opportunities to freely choose their own actions and therefore stand in loss of the autonomy and exercise of reason which makes them uniquely human.

Within the Western capitalistic democracies, especially in the U.S., the concepts of rights and autonomous, freely choosing individuals are central not only to the problems of political prisoners, hostages, and terrorism in the international arena, but to virtually all of our pressing national ethical issues as well. Speaking broadly, the abortion controversy is usually couched in terms of whether fetuses may be said to have rights, and if so, whether those rights take precedence over the rights of women to control their own

bodies.[2] Issues surrounding suicide and terminally ill patients are commonly analyzed by asking when, if ever, the rights of the individual to decide matters affecting his or her own life and death may be overridden by doctors or others on the basis either of sound medical practice or the premise that where there's life, there's hope.[3]

Turning to environmental concerns, ecologists of varied persuasions commonly defend their positions by appealing to the rights of our descendants to inherit a maximally healthy and genetically diversified natural world,[4] and with respect to animals, a number of philosophers and others are asking whether or not animals may be seen to have rights, rights which place sharp constraints on our right to manipulate them and/or the natural environments in which they live.[5]

And finally, it is not too grand a generalization to say that a number of domestic, ostensibly political issues—e.g. welfare, tax reform, capital punishment, affirmative action—reduce to a more fundamental ethical tension between individual rights and social justice.[6]

This conceptual framework in which the concept of rights occupies such a prominent position is so central to the moral and political ways we think that any attempt to challenge the whole of it will probably be construed metaphilosophically as impossible, and at the moral and political level, will probably be construed as either the dying gasps of the Stalinist left, or the resuscitated gasps of the fascist right.

The metaphilosophical problems of cognitive relativism are very important,[7] but must remain outside the scope of our immediate concerns, for it is moral and political issues that must be kept in focus. While I have no desire to be

labeled either a Stalinist or a fascist—or a liberal or conservative, for that matter—I do believe the conceptual framework within which rights-oriented moral and political theories find their place is fundamentally flawed and consequently I should like to briefly sketch out a challenge to it, and then even more briefly, sketch an alternative deeply embedded in Chinese culture—and not entirely alien to our own.

To begin, even if we assume that there is nothing wrong with the concept of rights, we must face the problem of exporting it, making it universally understood and appreciated.

Clearly the concept of rights, and of human beings as autonomous, freely choosing rights-bearing individuals, is identified with one major culture, Western civilization. Some scholars have tried to find traces of the concept in the writings of the early Greeks, others in St. Augustine and elsewhere, but the concept as we have inherited it today has its intellectual genesis in Locke's *Second Treatise on Civil Government*, and first found political expression in the Virginia Declaration of Rights, the Declaration of Independence, and the French Declaration of the Rights of Man.

A major effort to universalize the concept of human rights was undertaken by the victorious allies at the close of World War II, seen in the United Nations Declaration of Human Rights. The Preamble is particularly noteworthy in this respect:

> Now therefore the General Assembly proclaims this universal Declaration of Human Rights as a common standard of achievement for all peoples and all nations to the end that every individual and every organ of society keeping this declaration constantly

in mind, shall strive by teaching and education to secure respect for these rights and freedoms, and by progressive measures national and international, to secure their effective recognition and observance. . . .[8]

Note the key expressions here: "standard of achievement"; "shall strive by teaching and education"; "by progressive measures national and international." Clearly the framers of this Declaration, overwhelmingly drawn from the culture of the Western capitalist democracies, were concerned to propose a particular moral and political perspective, an ideal not yet extant, as the standard toward which all nations, and all peoples, should strive.

Now, forty-four years after the U.N. Declaration was promulgated, the ideal is still not extant. Although in one sense we can be seen as sharing a global village, it nevertheless remains the case that almost three-quarters of the world's peoples have no intimate acquaintance with the cultures of the Western capitalist democracies. They never have lived, do not now live, and, because of economic, environmental, and other circumstances, almost surely never will live in a post-modern, post-industrial cultural context. And if, as is true, most of these peoples live in cultures that do not have philosophical and/or religious traditions which incorporate something like the concept of human rights, or if they have concepts incompatible with the concept of human rights, then how could, or should, the members of those cultures come to see what it would be like to have rights, or, more pointedly, to see that conceiving human beings as rational, autonomous, individual rights-bearers was morally superior to their traditional views of what it is to be a human being?

Force, certainly, is one answer to these questions.

Through the manipulation of economic resources, and/or through military actions, the concept of rights and respect for rights on the part of governments can perhaps be extended beyond the Western industrial societies. Such has often been the justification for interventionist foreign policies of, especially, successive governments of the United States, from the occupation of the Philippines in 1899 to the occupation of Iraq in 1991. For the most part, however, the legacies of these foreign policies have been monstrous: economic and political exploitation of poorer peoples; cultural subjugation; the regular subversion of governments of other sovereign nations; large-scale degradation of many natural habitats; and human death—death in the millions, including a great many Americans who had no part in formulating those policies.

For those who accept this depressing characterization, coercive efforts to extend "the American way of life" to other peoples will not have much appeal, even if the motives of U.S. governments are much more truly noble in the future than they have been in the past.

Eschewing coercion, then, we must attempt to *persuade* others that rights-oriented moral and political theories are superior to others. This might be a fairly difficult task, for a number of reasons. In the first place, the view of human beings as autonomous, rational individuals would be seen by a great many of the world's peoples as simply false. Utilizing an impoverished—and largely bureaucratic—technical vocabulary emphasizing law, abstract logic, the formation of policy statements, and employing altogether implausible hypothetical examples, contemporary rights-based moral

and political philosophies, it would be argued, are no longer grounded in the real hopes, fears, joys, sorrows, ideas, and attitudes of flesh-and-blood human beings. Since the time of Descartes, Western philosophers have increasingly abstracted a purely cognizing activity away from concrete persons and determined that this use of logical reasoning in a disembodied "mind" is the choosing, autonomous essence of individuals, which is philosophically more foundational than are actual persons; the latter being only contingently who they are, and therefore of no great philosophical significance.

I suspect that for most of the world's peoples, however, there are no disembodied minds, nor autonomous individuals; human relationships govern and structure most of our lives, to the point that unless there are at least two human beings, there can be no human beings. By these lights, the writings of virtually every Western philosopher from Descartes to the present can only be seen as incantations for exorcising the human ghost from the calculating machine. To advance this point is not to decry the Western intellectual tradition; but it is to suggest that the contemporary philosophical and social scientific stereotype of a disembodied, purely logical and calculating autonomous individual is simply too far removed from what we feel and think human beings to be, it has raised problems that seem incapable of solution, and it is therefore becoming increasingly difficult for moral, social, or political philosophies embodying this stereotype to have much purchase even on Westerners (see below), not to mention the peoples who do not live as inheritors of the Western philosophical tradition; it is not for

nothing that a number of good philosophers have said that philosophy was dead—meaning Western philosophy.[9]

We must pursue this issue in greater depth, because this stereotype does not fail descriptively merely for contingent reasons; it must fail necessarily. It is admitted on all sides that human beings are not simply self-conscious and capable of reason, they are agents, which means they can act purposefully, and will act in different ways depending on what purposes they have. Purposes are ends, and there is a great multiplicity of possible ends one might strive to achieve. The problem arises when we ask how we can decide which ends we ought to strive to achieve, because of the persuasiveness of Hume's argument that no imperative statement (encompassing values) is logically derivable from any set of declarative statements (encompassing facts). It has long remained unquestioned, that to decide how to act it is not enough to be aware of things as they objectively are. Something more is needed to get to values, but what? And from whence can it come? Hume's position (in the *Treatise* and the *Enquiry*, at any rate) entails that answers to these questions must be "nothing," and therefore "nowhere"; our values are ultimately ungrounded.

The spell of this problem of seeing a gulf between facts and values was indeed first cast by Hume, but its enchanting powers derive from Descartes's view of what it is to be a human being, Hume's anti-Cartesianism notwithstanding. The plausibility of this form of skepticism about values requires that we see human beings as having bodies, each with a specific shape, weight, color, and spatial and temporal location, bodies which generate a mixed set of impulses, emotions, passions, attitudes, and so forth. Hovering over

and above each of these lumps of matter and messy assemblages of psychological states is a pure (because disembodied) mind, supremely competent to ascertain how things are (the objective world of fact/science), and how things must be (the necessary world of logic/mathematics), but— Hume's contribution—altogether worthless for determining how things ought to be (the world of ends/values). The break between mind and body is total. Moreover, the bodies we have are obviously contingent upon the way the world happens to be, and are subject to all of the causal laws which govern this contingent world; and how could such contingently existing, causally determined lumps of matter have value, be the source of value?

In one sense, it is philosophically irrelevant whether we accept this picture of human beings as literally true, or simply as a Western conceit useful for theorizing about basic issues, akin in large measure to Hobbesian capitalists in a state of nature, or Rawlsian statesmen behind a veil of ignorance, or Quinean linguists who can never be certain of the meaning of 'gavagai'. Whether seen as fact or fiction, the picture is one of a sense-absorbent and logically calculating mind altogether discontinuous with an emotively evaluating (but probably valueless) body, with no moral, aesthetic, or spiritual equivalent of the pineal gland to bring them, or facts and values, together.

This Cartesian picture of what it is to be a human being has dominated Western moral, aesthetic, and religious thinking for almost three hundred years. Kant accepted much of the picture, but recoiled from a major inference Hume drew from it, namely, that reason had to be the slave of the passions. Instead, he endeavored to ground ends (and values)

on purely rational grounds, insisting that reason be the master of the passions.

But Kant's reason can no more generate, or create values, than Hume's. Being purely formal, both the categorical imperative and the kingdom of ends principle do not, strictly speaking, embody values, and Kant's arguments for them do not rest on any basic values, but on the fear of logical self-contradiction which would follow from rejecting them. Reason, in short, is necessary instrumentally—to help us achieve goals—and it can be of assistance in ordering or re-ordering our values; but create values it cannot, and hence if we believe that human beings are, or can be, purposeful agents, we cannot simultaneously believe that they are altogether autonomous, disembodied, individual rational minds.[10]

To this critique any rights theorist would probably reply that of course the Enlightenment model of the rational, autonomous individual isn't to be seen as descriptive of human beings, but rather prescriptive. Obviously, people have values and just as obviously different cultures embody different values, which is what makes moral relativism the acute problem that it is today. By focusing on rationality, this reply might continue, and by showing the rationality of the concept of rights, we can hope to overcome what separates us (cultural differences) on the basis of what unites us (the capacity to reason); and we can hope thereby to overcome most, if not all, of the problems of moral relativism by establishing the reasonableness of the view of human beings as rational, autonomous individuals, and as rights-bearers, no matter what their cultural background. The view is not descriptive, but normative: we *ought* to accept it.

The force of this imperative, however, weakens as soon as we look carefully for the moral relativism it is designed to overcome. Elsewhere I have argued,[11] on logical grounds, that true instances of moral relativism can arise only when two peoples employed the same or very similar evaluative concepts and criteria, and that one people approved a particular human action, and the other disapproved.

How many such examples of true moral relativism there may be between different peoples around the world I don't know, but suspect the number has been greatly exaggerated (think again of Chinese and Iraqi grandmothers). Unfortunately we do not have to trek to exotic lands to find examples, however, for they are everywhere in contemporary American society. As hinted at the outset, abortion is a prime example. Within the conceptual framework of rights-based moralities, with its concomitant concepts of duty, rationality, autonomy, choice, self, and freedom, it may be impossible to resolve the issue of abortion. One might want to argue that abortion is fundamentally a legal and not a moral issue, but for good or ill the vocabulary utilized in discussing the issue stems from the same conceptual framework. The matter could not be otherwise, for when both sides claim that basic human rights are at stake, then we cannot but have a paradigmatic moral issue. Nor can it be objected that abortion is an instance of moral conflict, not moral relativism, for this objection misses the logical point: an abortion is a human action tolerated by a fairly large number of people, and loathed by another large group; precisely the same situation described in all purported instances of moral relativism based on anthropological evidence.

The examples can be multiplied, again, as hinted at the outset; animal rights, euthanasia, the rights of the not yet born to a healthy and genetically diversified natural environment; all of these and other issues are sharply dividing the American peoples, and our inability to effect reconciliation may well be due to the conceptual framework within which the dialogues and diatribes occur. More generally, where the moral and the political realms intersect—justice and fairness—there is even more *prima facie* evidence for irreconcilable differences, leading to the conclusion not that those who disagree with us are stupid, selfish, or evil, but rather to the conclusion that individual rights and social justice are very likely incompatible concepts when their implications are drawn out.

Other arguments can be advanced against the rational, autonomous, rights-bearing individual as a model of human beings, taken either descriptively or prescriptively. One of these is well known from work in Prisoner's Dilemma games, and from rational choice theory more generally.[12] If we add to the Enlightenment model of human beings— which virtually all thinkers since Hobbes have done—the additional quality of being self-interested, then, for a wide range of nonexcludable collective (or public) goods (or benefits), everyone behaving rationally *guarantees* that the collective good will never be obtained, and everyone will be worse off. Consider the streets of New York and other major U.S. cities. They are filthy, drug-filled, and dangerous. If would be a great collective or public good for the people of New York to clean up and reclaim their streets. But given that no one can be excluded from the streets, no *rational, self-interested* individual will elect to contribute to the reclama-

tion project. The streets will either be cleaned up, or they will not. If they are, the self-interested individual will enjoy the collective good without having to pay the costs of contributing. If the streets remain as they are, the individual has saved the costs of contributing. Each rational, self-interested individual must therefore decide not to contribute. And the streets of New York will remain as they are, and every individual will be worse off.

A great many attempts to escape from this and other "free rider" or collective action paradoxes have been made, all of them unsuccessful, suggesting that the streets of New York and other U.S. cities will only continue to deteriorate unless and until some new (or very old) ways of thinking about moral and political issues gain currency.

It can be noted in passing that here we have another Chinese meaning for "bourgeois liberalism." To be sure, the present Politburo members regularly use the expression as a shibboleth to mask the horrors they have visited on Chinese (and minority) dissidents. But the expression can, and must, also be seen theoretically as shorthand for the Enlightenment model of human beings, with its resultant "paradoxes" of collective action; crowded, noisy, and cluttered though they may be, the streets of Shanghai remain a far more human habitat than the streets of New York. The plight of the dissidents requires our strong support for them at this time, coupled with moral condemnation of the actions of the government. But eventually the theoretical issues will have to be faced— especially by those who support and condemn solely for reasons articulated within the modern conceptual framework encompassing human rights.

For the past three hundred years an enormous body of

literature has been produced assuming, elaborating, and defending political and moral views based on human beings being autonomous, rational, rights-bearing, and self-seeking individuals. Clearly I have not even begun to respond to the whole of that literature in this very brief and general critique. But because so much of that literature presupposes the Enlightenment model of human beings as purely rational, self-seeking, autonomous individuals, the many arguments and views in that literature cannot have more plausibility than the basic assumptions on which they rest. To be sure, that model—especially as it has been taken to imply human rights—has advanced significantly the cause of human dignity, especially in the Western democracies, but it also has a strong self-fulfilling prophetic nature, which is strengthened further by the demands of capitalist economies (a point to which we will return); and I believe that model is now much more of a conceptual liability than an asset as we approach the twenty-first century, continuing our search for how to live, and how best to live together on this increasingly fragile planet.

This critique could be broadened and deepened considerably, but I should like to shift the focus now to an alternative view of human beings. In doing so I follow the example of Leibniz, one of the few Western philosophers who took non-Western philosophy seriously. In his *Discourse on the Natural Theology of the Chinese*,[13] and in much of his correspondence, Leibniz maintained that the Chinese were a rational, moral, and spiritual people with a rich and ancient heritage, sufficiently so in all of these respects that it would be sheer madness to insist—as Matteo Ricci's successors at the China Mission were insisting—that the Chinese would have to

altogether abandon their heritage in order to become good Christians. To be sure, in making his case Leibniz was simultaneously siding politically with the Riccian accommodationists in the Rites Controversy. But he was also doing something more. He was arguing that most Chinese views were fully compatible with European views, despite the enormities of the differences between their languages, history, customs, and culture. (He often referred to China as the "anti-Europe".) His meta-argument ran as follows: China and Europe can be placed at extremes, and all other cultures placed on a continuum from one to the other. If it can then be shown that Chinese and Europeans have, at a very basic level, compatible views about the universe and the place of human beings in that universe, it must follow that there is hope for all peoples in all cultures to share those basic views.

The specific Chinese views Leibniz analyzed at length were of course Confucian views, and I will do the same, albeit in a much more adumbrated form. If we reject the view of human beings as free, autonomous, rights-bearing individuals, what are the alternatives? If I could ask the shade of Confucius "who am I?" his reply, I believe, would run roughly as follows: given that you are Henry Rosemont, Jr., you are obviously the son of Henry, Sr., and Sally Rosemont. You are thus first, foremost, and most basically a *son*; you stand in a relationship to your parents that began at birth, has had a profound effect on your own and their later lives as well, and it is a relationship that is diminished only in part at their death.

Of course, now I am many other things besides a son. I am husband to my wife, father of our children, grandfather

to their children; I am a brother, my friend's friend, my neighbor's neighbor; I am a teacher of my students, student of my teachers, colleague of my colleagues.

Now all of this is obvious, but note how different it is from focusing on me as a purely rational, rights-bearing autonomous individual. For the early Confucians there can be no me in isolation, to be considered abstractly: I am the totality of roles I live in relation to specific others. Moreover, these roles are interconnected in that the relations in which I stand to some people affect directly the relations in which I stand with others, to the extent that it would be misleading to say that I "play" or "perform" these roles; on the contrary, for Confucius I *am* my roles. Taken collectively, these roles weave, for each of us, a unique pattern of personal identity, such that if some of my roles change, others will of necessity change also, literally making me a different person. Marriage made me a different person, as did becoming a father and then a grandfather; and divorce would make me a different person also.

Further, my role as father, for example, is not merely one to one with my daughters. In the first place, it has a significant bearing on my role as husband, just as the role of mother bears significantly on my wife's role as wife. Second, I am "Samantha's father" not only to Samantha, but to her friends, her teachers, someday her husband, and her husband's parents as well. And Samantha's role as sister is determined in part by my role as father.

Going beyond the family, if I should become a widower, both my male and female friends would see me, respond to me, interact with me, somewhat differently than they do now. A bachelor friend of mine, for instance, might in-

vite me as a widower to accompany him on a three-month cruise, but would not so invite me so long as I was a husband.

It is in this epistemologically and ethically extended meaning of the term "roles" that the early Confucians would insist that I do not play or perform, but am and become the roles I live in consonance with others, so that when all the roles have been specified, and their interconnections made manifest, then I have been specified fully as a unique person, with few discernible loose threads from which to piece together a purely rational, autonomous, rights-bearing individual self.

Moreover, seen in this socially contextualized way, it should become clearer that in an important sense I do not achieve my own identity, am not solely responsible for becoming who l am. Of course, a great deal of personal effort is required to become a good person. But nevertheless, much of who and what I am is determined by the others with whom I interact, just as my efforts determine in part who and what they are at the same time. Personhood, identity, in this sense, is basically conferred on us, just as we basically contribute to conferring it on others. Again, the point is obvious, but the Confucian perspective requires us to state it in another tone of voice: my life as a teacher can only be made significant by my students; in order to *be* a friend, I must *have* a friend; my life as a husband is only made meaningful by my wife, my life as a scholar only by other scholars.

This is a woefully brief account of one basic element of early Confucianism.[14] But if it at all accurately captures the thrust of the classical texts, I would suggest that those texts

reflect a view of what it is to be a human being—Chinese of American, young or old, male or female, capitalist or socialist, past or present—that is probably more realistic and humane than the view of us as purely rational, autonomous, rights-bearing individuals. And it should go without saying that even after a century and a half of "Westernization" and Marxism, this view remains of overarching significance in contemporary China.

To be sure, my account has also been fairly one-sided. How, it might well be asked, would I deal with the manifold shortcomings attributed to that philosophy? Late classical and imperial China were obviously Confucian, yet were a long way from Paradise. Confucianism reinforces patriarchy, hence is sexist. It is hierarchical, hence elitist. And it is particularistic: it provides sound guidelines, perhaps, for dealing with one's family, neighbors, and friends, but says nothing about how to get on with strangers; hence it develops no sense of the public, or civil community, and hence in turn it provides no checks on a government's ability to do with its population whatever it wishes to do.

Briefly sketching responses to these criticisms, first, the early Confucian ideal was never realized, even approximately, in imperial China. That history was replete with authoritarian rulers, self-serving officials, exploitative parents, dull pedants. But none of these types of people ever receive praise in the classical texts; on the contrary, they are explicitly condemned, without equivocation. (Moreover, I am concerned first and foremost with the conceptual framework of early Confucian philosophy, and consequently, to some extent at least, historical issues are at best only indirectly relevant to assessing that philosophy. While Plato and

Athens were inextricably linked, Platonism and Athenian history are distinct, and from the mere premise that the Confucian ideal was not realized, it surely does not follow that it could not be.)

The Confucian ideal must of course be modified significantly if it is to have any contemporary purchase in China or elsewhere, for the charge of patriarchy is well taken. Confucius and his followers were clearly sexist as we use the term today, and all efforts at reconstructing the Confucian persuasion must excise those elements of the tradition that assign women inferior roles. The task, however, may not be impossible, because however specifically sexist Confucianism was and is, the thrust of it is not competitive individualism—which is associated in the West with maleness—but rather other-directed, and nurturing—which is associated in the West with the feminine.

We might go even further in this regard, revising, but keeping the central role of the family that dominates the tradition. One can certainly have not only the concept of the family with the concept of sexual equality; we can also expand, and still keep the concept of the family by allowing for two, and perhaps more parents or nurturers of the same sex. Homophobia was, and still is, as characteristic of the Chinese tradition as sexism was, but gays and lesbians too are the sum of the roles they live in and out of the family, and the conceptual framework of Confucianism would surely be impoverished by their exclusion, enriched by their inclusion.

To see these points in another way, consider the next criticism against Confucianism, that it is hierarchical, and consequently elitist. I believe the charge is misplaced. It is usually

couched in terms of human relationships being based on roles that are described as holding between "superiors" and "inferiors," or between "superordinates" and "subordinates." But when we look at the texts closely for guidance in how to properly fulfill our roles as parents and children, teachers and students, etc., and when we keep in mind the central role of reciprocity in early Confucianism, we might want to change the descriptive terms of the relationships as holding between benefactors and beneficiaries. And if we keep equally in mind that we are all of us some of the time benefactors and some of the time beneficiaries, then much of the sting of the accusation of hierarchy or elitism goes away. Again, I would maintain that this account is a fairly realistic one: I am largely a beneficiary of my parents, benefactor to my children; the same holds as between my teachers and my students; and I would also argue that upon close inspection, even the relationships between friends, neighbors, and colleagues can be cogently analyzed in this way.

Much more, of course, needs to be said about all of these matters, but I turn now to the remaining charge, that of particularism. I do not believe Confucius only worried about one's obligations toward specific others. On the contrary, I believe he had a strong sense of, empathy with, and concept of humanity writ large.

All of the specific human relations of which we are a part, interacting with the dead as well as the living, will be mediated by the courtesy, customs, and traditions we come to share as our inextricably linked histories unfold, and by fulfilling the obligations defined by these relationships we are, for early Confucians, following the human way. It is a

comprehensive way. By the manner in which we interact
with others our lives will clearly have a moral dimension
infusing *all*, not just some, of our conduct. By the ways in
which this ethical interpersonal conduct is effected, with
reciprocity, and governed by civility, respect, affection, cus-
tom, ritual, and tradition, our lives will also have an aes-
thetic dimension for ourselves and for others. And by specif-
ically meeting our defining traditional obligations to our
elders and ancestors on the one hand, and to our contempo-
raries and descendants on the other, the early Confucians
offer an uncommon, but nevertheless spiritually authentic
form of transcendence, a human capacity to go beyond the
specific spatiotemporal circumstances in which we exist,
giving our personhood the sense of humanity shared in
common, and thereby a sense of strong continuity with what
was gone before and what will come later. There being no
question for the early Confucians of the meaning *of* life, we
may nevertheless see that their view of what it is to be a
human being provided for everyone to find meaning *in*
life.[15]

I submit that this ancient Confucian view of what it is to
be a human being much more closely resembles the views of
three-quarters of the world's peoples than does the Enlight-
enment model, and it is real and robust enough to allow for
a full condemnation of government repression, hostage tak-
ing, acts of torture, terrorism, and much more that is evil,
without ever invoking the concept of human rights. I would
go further to suggest that the ancient Confucian view is not
even altogether foreign to the great majority of the inhabi-
tants of Western capitalist democracies; Confucian though it

sounds, it was after all, a Westerner who said that

> no man is an island entire of itself. . . . Any man's death dimin-
> ishes me, because I am involved in mankind, and therefore never
> send to know for whom the bell tolls; it tolls for thee.[16]

And I would go even farther to suggest that families, friends, neighbors, and fellow citizens might even be able to reclaim our cities' streets after they have been abandoned by rights-bearing, autonomous individuals.

Having polished the mirror a bit, we may now return directly to the question of what people of good will might hope for the Chinese.

A difference of taste. Street scenes in Shanghai, June, 1991.
Photos courtesy of Lisa Scheer.

IV | Tomorrow?

When I returned briefly to China in December, 1989, the political surface was calm, but the underlying discontent was palpable. Obliged to account for their activities during the "Beijing Spring," students told me they had to write lies about what they had done, and state beliefs they did not hold. They hated the system that was making them write such statements and they hated themselves for writing, all the more so as they knew their peers uniformly had the same feelings. Similarly, instructors and other intellectuals have said and are saying things about the glories of Marxism-Leninism and the economic reforms which are false, and which they know to be false. They hate the system that makes them do it, and they hate themselves for doing it, all the more so as they know that their peers uniformly have the same feelings.

Gradually the disgust and despair gave way to intense boredom, as the Party increased indoctrination efforts in an inverse ratio to their effectiveness. By the middle of 1990 the *Washington Post* could report:

A Communist Party cadre was lecturing to Chinese intellectuals [at the Chinese Academy of Social Sciences in Beijing] on a "very important" speech by General Secretary Jiang Zemin, but five or six in the group were sleeping. Two snored. Six or seven others read books or newspapers, while the remainder slumped in their

seats, visibly bored. According to a number of Chinese scholars, future generations may well look back on this time as a time in which some of China's best brains slept their way through an unpleasant experience. . . .[1]

Clearly, students and the overwhelming majority of intellectuals are antipathetic to the present government, and while a number of them are hoping for the return of Zhao Ziyang or someone like him, many more—especially among the young—have given up on the Party altogether.

Workers must know that the government campaigns against the "six evils" are but a band-aid, and do not even begin to address the underlying causes of those evils. They must also know that their recent small wage increases will undoubtedly trigger more inflation; keep them increasingly behind the level of earnings of pimps, black marketeers, and other entrepreneurial hustlers; know that the prosecution of corruption will remain desultory and stop well below the upper echelons of the Party and government; and know as well that their jobs will continue to be threatened.

And the peasants? I do not know, and I don't believe anyone else does either, including the members of the Politburo. Long inclined toward passivity, they could easily rise up if widespread famine should strike, especially in some of the poorest areas. The last two harvests have been good,[2] but a drought year could bring a rebellion, because Party authority has been weakened even more in the countryside than in the cities, owing both to the economic reorganization that accompanied decollectivization, and due as well to the greater concentration of the PLA armies in and around the cities—along with a beefed-up People's Armed Police— to prevent new urban uprisings.

Thus the government cannot be said to enjoy the esteem or affection of most of the governed; it surely does not enjoy their consent either. The government has other problems. First, there is no obvious successor to Deng Xiaoping after he finally passes to his reward, and there is no formal procedure for selecting one. It has the world's most bloated and perhaps least efficient bureaucracy, but it is not able to tax effectively, making it difficult to generate large amounts of revenue for capital investment or to maintain and expand the infrastructure, or to maintain and expand desperately needed social services. A further weakness, perhaps the most important, is that the Party of one-party government seems to have lost its vision. With the death of Deng and his cohort, the last of the Long Marchers will be gone, and even most of those who fought in the Anti-Japanese and Civil Wars as well. There does not seem to be any political or moral consensus among Politburo members, and discipline and morale are lax and low throughout all echelons of the Party.

Certainly there have always been factions in the Party, but most of the infighting was about tactics. A broad vision seemed to be shared in the past, and common enemies to struggle against, be these old-fashioned Chinese ways, the Japanese, the Guomindang, and/or Western imperialism. No shared vision is now discernible, and no one seems to know who the enemy is. Is it still old-fashioned ways? Fear of the Guomindang's economic beacon shining from Taiwan? The Cultural Revolution? Russians? Western neo-imperialism? With neither vision nor enemies it is difficult for a party to remain a party. (Seen in the light of recent events in Central Europe, it is impressive that the Chinese

communists held together as long as they did. The many and varied groups within each of the former Eastern Bloc countries were unified in their hatred of their Stalinist regimes, but it certainly didn't take long for their coalitions to fall apart once those regimes disappeared.)

To be sure, the government also has some assets, not the least of which is an unequaled capacity for repression through the People's Liberation Army, People's Armed Police, and the Public Security Bureau. And the sheer size and tendency toward inertia of the bureaucracy also contributes to a stability—whatever the cost—that the government, and perhaps a great many people, seek to maintain. Further, while the Chinese peoples do not see themselves as part of a nation-state as that concept is known in the West, they do participate in the world's oldest continuous culture, and the binding strength of this cultural cement is not to be passed over quickly.

These strengths of the government and the Politburo notwithstanding, I believe the latter are correct in fearing new uprisings, for new uprisings there will be. Whether they begin tomorrow, or at the death of Deng Xiaoping, or are triggered by some more mundane event I am not sure; but I believe they will come, because things cannot remain as they are, yet the government no longer seems capable of even knowing what to change, let alone how to effect change. Future uprisings may well be bloody, because there does not appear to be any faction within the Party that would be trusted enough to be capable of restoring order peacefully, no other organization in China has either the numbers or political apparatus to take over, and on the basis

of my limited experience, there is little interest or enthusiasm inside the country for the "government-in-exile" opposition groups that formed in France and the U.S. after Tiananmen.[3]

The violence might be massive, and sustained, because as already noted, the government, while weakened considerably, is by no means impotent. It could remain in power by inaugurating a reign of terror akin to Stalin's. This would be a morally loathsome state of affairs, even if it did not have disastrous economic consequences, which it almost surely would.

On the basis of these considerations, my first hope for the Chinese is that students and intellectuals will be able to overcome their elitist prejudices against workers to the point of being trusted by the latter sufficiently to make common cause in the cities, not to destroy the Party, but to break once and for all the Party's stranglehold on the country, and that they will be able to accomplish this with the aid of PLA forces, without large-scale violence. There are no good grounds for believing, however, that these groups could remain united enough thereafter to run the country effectively, with the consequences of power vacuum followed by a loss of central governmental authority; and it is my second hope that this is exactly what will happen.

Throughout Chinese history, as dynastic central authority grew weaker, the periphery—the provinces—grew stronger, and perhaps it is time for history to repeat itself. To my mind, a dozen or so "little Chinas" will necessitate the making of fewer moral compromises than one big one. In the economic realm regionalism has already been growing apace for the last several years, and in my opinion this movement

offers more promise to the Chinese peoples than the continuation—or worse, strengthening—of an authoritarian central government that cannot govern, but only maintain itself through fear and/or force.

A number of strong objections can be made against this position. First, there is definitely a possibility that history would *fully* repeat itself, and China would enter another "warlord" period, as dismal as the earlier one. Second, the several "little Chinas" would probably have unequal rises in living standards. I would guess that Guangdong, Shenzhen, the Dongbei area, Shanghai, and the coastal regions of Fujian, for example, would forge ahead, while areas like Guizhou, Shandong, Lanzhou, and the interior of Fujian would fall behind. Third, a number of the "little Chinas," even the economically stronger ones, might not be capable of withstanding the depredations of multinational corporations, and become wholly owned subsidiaries of them in everything but name. And finally, the idea of regionalism would be repugnant to most of the Chinese intelligentsia, who have been inheriting the concept of "All under Heaven" ever since the classical *Book of History* began to be written three thousand years ago.

All of these are very good warrants for skepticism about the desirability of decentralization in China; I do not take them lightly. Lest the point get lost as we continue, however, let me reiterate my fear that a strong central government can only continue by becoming increasingly repressive, and that decentralization is therefore a preferred moral alternative by default, if for no other reason; those who would reject my hope for "little Chinas" must thus have some confidence that my fears are more or less groundless. (In its most recent

report on China—June 4, 1991—Amnesty International stated that religious and political repression there had increased over the past two years: "It's not uncommon for people out of the spotlight, ordinary activists or those tried outside Beijing, to be jailed for 10 to 20 years, sometimes simply for making dissident speeches.")[4]

The several warlords of the late nineteenth and early twentieth centuries were different from one another in many respects, but were all appropriately designated, because they did make war. I do not think it will be possible for history to fully repeat itself in this way, for at least two reasons. First, the geopolitics are very different now. While none of the major imperialist nations had the capacity to annex the whole of China as a colony, they all wanted "spheres of influence" within which they would be economically and politically dominant (John Hays's "Open Door" notes on behalf of the U.S. are not a relevant exception).[5] The desire for such spheres led the imperial powers to seek out and support—with supplies, weapons, etc.—local strongmen, the fathers (sometimes literally) of the later warlords. But I think the world has changed too much geopolitically and technologically in the past century for a similar situation to obtain today.

My second reason for doubting that a number of "little Chinas" might lead to a rebirth of warlordism, related to the first, is that large, well-equipped armies are simply becoming too expensive to establish and maintain, and they eventually wreak economic havoc in their homelands. Mikhail Gorbachev seems to have been the first political leader to realize this,[6] and I think it will soon be realized by Lithuanians, Serbians, Armenians, and other independence-minded

ethnic groups as well. (And I further believe this principle is well understood by a great number of Americans, despite the jingoism of the U.S. government, broadcast by the media, during the Iraqi war.)

This point can be seen in another way by looking at the two capitalist giants that have grown up since the Second World War: West Germany and Japan, both of which have had small defense budgets in the past, the United States serving as their "protector" instead; and much the same may be said for South Korea and Taiwan after World War II. (Singapore has a relatively small defense force, and Britain maintains military responsibility for Hong Kong.)

The economic burden placed on a country by maintaining a large military establishment also bears on another of the objections to regionalism, namely, that even though some of the regions of China—or Central Europe, or the U.S.S.R.—might prosper more, and more rapidly, than others, nevertheless, if they were not saddled with large standing armies they could all prosper to some extent, with the poorer regions almost surely being better off than they are at present (if not greatly "better off" economically, then socially and politically, a point which I will take up below).

We have all been conditioned to view the breakup of nation-states into smaller units as bad; big is beautiful. But why? If the U.S.S.R. ceases to exist as an entity, or Yugoslavia, for example, what dire consequences would have to follow? Surely we must be saddened by the ethnic dislikes and distrust that are being expressed by different peoples in these areas, and we must be sobered by the speed and strength with which they were given overt expression after being submerged for a half-century under socialist rule.

(This does not apply to China; the Han people are certainly chauvinists, but they do not *hate* the minorities in their midst.) But if Yugoslavia breaks up into six independent smaller nation-states, especially if the majorities in each of them so wishes, why should anyone else be upset?

One answer to this question, of course, is that it would become more costly and difficult for multinational corporations to conduct international business under such arrangements, which is very probably why the U.S. media so consistently slant the coverage of such tendencies toward bemoaning them. The vast majority of corporations with offices in China pared down, but did not close up, following the Beijing slaughter; they did not want Bush to impose strong sanctions (he didn't), and they want him to continue supporting most-favored-nation status for the country (and he does). These corporations favor a strong central government in China—and in the Soviet Union, and elsewhere—which is responsive to capitalist investment. Under such conditions, there are relatively few people to deal with, stability is more assured, continuity guaranteed, and economies of scale to be obtained, all of which maximize profits. This point should be emphasized. Those who insist on a transition from a command to a free-market economic system *never* suggest that the governments stop investing, because if they did, no transitions could occur (and foreign investment would be unsupported and unprotected). Capitalist investors, and the economists who support them, uniformly want the formerly socialist governments to make many but different investments than they did before.

My account of multinational economic matters is admittedly oversimplified here, but my focus is not on the subtl-

eties of how they operate; rather is my focus on the peoples who would comprise smaller political groupings if they seceded from their unions, or at least sought greater autonomy therefrom: what adverse effects, economic or otherwise, would these arrangements generate such that we should deplore them?[7]

The case for more regional autonomy can be strengthened considerably when we take up what I assume is a universal moral value: the necessity of having people democratically participate actively in the making of decisions that directly affect their lives. The Chinese have long held to the principle of cooperation at the family, clan, and village level, but there is no tradition of a *public* in the country, no strong *civic* sense that begets *citizens* (the Chinese word *gong*, now translated as "public," originally denoted a clan leader, and by extension, the dwelling place of a clan leader). This suggests that if anything like genuinely democratic institutions and traditions are to develop in China—or elsewhere—they will have to develop where they have an analogue: at the local level; people assuming real control of their own lives has always been a bottom-up and not a top-down endeavor. And we can note in passing that the role of citizen is a fairly natural extension of others, like friend, fellow-worker, neighbor.

Such control, I submit, cannot be assumed when a large, repressive, and distant government is in power. In post-Liberation China, there was a decentralization of sorts both during the Great Leap Forward and the Great Proletarian Cultural Revolution; with sordid results overall, as noted earlier. In communist theory, "democratic centralism" requires *some*

form of local democracy, else there would be no inputs to the center. And I believe democratic centralism was a deeply held conviction for Mao Zedong. But by the early 1950s Mao did not trust large segments of the mid- and upper-level cadres in the Party, and democracy—in Mao's sense—was a splendid ideological base from which to shake loose the power and authority of those cadres. At the tactical level, Mao *could* have endeavored to weaken the growing power of the Party itself, but this he could not bring himself to do, and consistently from the time of the Great Leap, he attempted instead to assume more power himself—eventuating in what is correctly described as the "cult of personality"—which prevented the continued development of genuinely democratic procedures and institutions at the local level.[8]

But just as we obscure our vision of China by merely condemning the Politburo for the horrors of June 4th, so will we equally obscure it if we merely condemn Mao for the horrors of the Great Leap and Cultural Revolution periods. Returning to William Hinton's analyses of the Chinese countryside, he maintains that during the years of the Cultural Revolution (1967–76), under full collectivization, the results were not economically disastrous. On the contrary, he estimates that economic conditions improved consistently and considerably in about 30 percent of the rural areas, remained about the same in 40 percent, and worsened in the remaining 30 percent.[9] These figures indicate to me that if privatization policies were to be established, they should have been implemented where the peasants wanted them, in those areas where full collectivization wasn't proving to be effective for raising living standards. But Deng's "commandism,"

which he could enforce because he controlled a strong, central government and Party, required privatization for *all* Chinese agriculture, whether the peasants wanted it or not; and contrary to a fundamental assumption of capitalist theory—self-interested autonomous individualism—many peasants did not.[10]

Moreover, even following the de-collectivization of agriculture, a number of rural areas have maintained and enhanced their public projects, from water conservancy operations to village parks, meeting halls, and other facilities for economic and recreational use. Still being very poor by the standards of the industrial countries, it is of course in the self-interest of the peasants to support these works; the support is nevertheless a major step along the way to citizenship.[11] Further, even a Chinese group very different from the peasantry—Shanghai dockworkers—had no conceptual or other difficulties in simultaneously seeking better living and working conditions during the Cultural Revolution, while at the same time being committed fully, the principle of equalitarianism.[12]

These examples, and they could be multiplied, provide at least some grounds for believing that the breakdown of central authority in China would not result in chaos, or a dog-eat-dog existence for the Chinese peoples.[13] There are other grounds as well. At a philosophical level, it must be the case that the larger the political unit, the higher the probability the members of that unit will have few values in common, and the converse also holds: the smaller the unit (Serbians, Sioux, Sichuanese), the greater the number of shared values. And I would argue, as a corollary to this view, that the greater the number of values shared by a community, the

more will its members see themselves as nurturing and nur-
tured role-bearing persons within that community, rather
than as rights-bearing autonomous individuals set more or
less against the community.

If my philosophical views here have any merit,[14] they
suggest a somewhat different philosophical view of democ-
racy. People living in the capitalist industrial countries are
strongly inclined—thanks to much social science scholarship
and philosophical writings in those democracies—to think
of politics as akin to economics. Just as we express our per-
sonal preferences with our money in the economic market-
place, so do we express our personal preferences with our
votes in the political arena. (In one sense, the analogy holds:
seldom do we have real choices to make in either place.) But
imagine a community with widely shared values. Primary
among these values would be a conception of the good
life, and the shared belief that such a life was good over
and above personal preferences. In such a community the
desired would not be equated with the desirable, and demo-
cratic political participation—being a citizen—would in-
volve engaging in collective dialogue about the appropriate
means for achieving agreed-upon ends.

However unusual they may seem at first, these ideas are
not counterintuitive. At least in part, a community is defined
by its members' common adherence to a conception of the
good life for human beings (hence questions about whose
conception would prevail are beside the point). These con-
ceptions are inculcated in the young, are often never made
explicit, and are surely vague. Moreover, a number of these
conceptions have traditionally included a denial of the full

good life to people of a different color, sex, etc. But these observations should not lead us to reject the significance of conceptions of the good life, for people do indeed have them, and, more important, it is highly probable that these conceptions would be modified, perhaps greatly, as they had to be articulated clearly in the course of democratic political engagement: it is one thing for a racist to vote for another racist by secret ballot; it is something else altogether to be obliged to publicly state and defend one's racism, even within one's own community.

Nor is the belief that there is such a thing as the good life over and above individual preferences an unusual one. Surely there are many ways to be a good parent, friend, neighbor, spouse, and so forth, but there are strong constraints nevertheless; child abusers earn and deserve moral opprobrium significantly because parents—true parents—do not abuse their children. Similarly, I believe there are a set of specifiable actions—however different the specifications might be for different people—such that one would prefer to die rather than perform them, if performance was necessary to continue living (a gross example: being obliged to torture one's parents daily). If so, it follows that each of us does, in our own way, believe that there is such a thing as the good life over and above our own, or anyone else's, individual conceptions thereof.

Returning specifically to China again, I take it as noncontroversial that conceptions of the good life are widely shared in its several regions. Differing in particulars, the age-old Confucian dream, taken over by Mao,[15] continues to be one of the things that make more than 700 million Chinese peasants Chinese (and is perhaps common to peasant

farmers the world over). A strong central government, especially as it insists upon a very different conception—or has no conception of the good life at all—will neither promote local democracy, nor diversity; and hence such a government cannot be our highest moral hope for China, even if its repressive measures stopped short of employing terror to secure conformity with its dictates.

And cultural diversity, like democracy, is, I believe, also morally desirable, as important for *Homo sapiens* as genetic diversity is for all species sharing this planet. Cultures are circumscribed at least in part by language, and the linguist Kenneth Hale has argued eloquently and at length for maintaining and enhancing linguistic diversity:

> . . . I will assume without further discussion that the purpose of humanity is to exercise to the greatest possible degree the intellectual powers which define its distinctive biological heritage, through the mental and material creation of the widest possible range of cultural products. And I will assume further, all things being equal, that anything that enhances this purpose is moral, and that anything that obstructs it is immoral. A number of things follow immediately from this. Thus, for example, the oppression of human groups and individuals violates the human purpose. And assuming that both breadth and depth are necessary to achieving the human purpose, its enabling condition is linguistic and cultural diversity. Only with diversity can it be guaranteed that all avenues of human intellectual progress will be traveled. From this it follows that local languages and cultures must be permitted to develop in accordance with the directions of progress which the communities involved define for themselves.[16]

These considerations strengthen further the case for greater autonomy for the several and varied regions of China. Its culture does not need further homogenization, and it would be good, even among the Han peoples, to

maintain local customs, traditions, and dialects. Weddings, funerals, and religious observances in Sichuan are not the same as those in Shanghai, and are different as well from those in Hailongjiang, or Guangdong; as are the dialects spoken in all these areas. And if we may hope for the continuation of linguistic and cultural diversity among the Han peoples, then all the more should we hope for it among the Muslims of Xinjiang, the Mongols of the grasslands, the minorities in Guizhou, Yunnan, and other areas, and hope it especially for the suffering Tibetans.[17]

And finally, the environment. I believe that China as a whole is simply too big, its topography too strained and too harsh, and its people too poor to pay the price—ecological and financial—of developing Western-style massive communications and transportation systems. There isn't the money for it, the environment won't endure it, and it can be argued that the Chinese certainly don't need it.[18]

If we include urban workers with peasant farmers, per capita income in China was approximately U.S. $300 in 1988. It is difficult to imagine profitably marketing an automobile, even using low-quality materials and highly exploited labor, for less than U.S. $3,000. How many times would per capita income have to *double* in China before her citizens could contemplate purchasing a car, even assuming zero inflation, and no other expenditures beyond present ones? Now suppose—per *impossibile*—that such an incredible growth of income occurred, and the Chinese purchased cars in proportion to ownership of them in the U.S. (geographically similar in size): there would be over *half a billion* automobiles in China. And they would be running on less than a million

miles of roads, both paved and unpaved. (By comparison, the U.S., with over 140 million registered cars, has 3.5 million miles of *paved* highways; and our major urban areas experience gridlock daily).[19]

Who would pay to build more roads in China, pave those already in existence, and maintain them? How would the Chinese afford oil and gasoline? What would another half billion automobiles do to the earth's atmosphere? More important, what would the Chinese use their cars *for*? In asking these questions I am not suggesting that we should leave the Chinese—and all other poor peoples around the world—in their poverty, while we go on attempting (unsuccessfully, eventually) to maintain our current standards of living, which for middle-class Americans means about two cars per family. On the contrary, I want to suggest that by reflecting on the Chinese situation, we can come to see such things as automobiles, so integral to the current U.S. way of life, in a different light.

To illustrate this point, and to take up again my view of democratic political engagement as centering around conceptions of the good life, we may continue with our example of the automobile, which has had, and has now, a profound impact on the economic and social structures of the United States, and with which most Americans have had a long-standing love affair. Are automobiles desirable? If the desired and the desirable are synonymous, as marketplace politics would have it, then the answer is obvious, for the vast majority of Americans desire automobiles—to get to and from their work, if for no other reason. And automobiles seem to give us more individual autonomy. But the continued production, maintenance, and use of automobiles

consumes large quantities of nonrenewable resources; they are expensive in their own right, expensive to maintain and to use, they generate much waste, require great tax expenditures for infrastructure development and maintenance, and contribute significantly to the fragmentation of neighborhoods and communities[20]—all of which suggests that under many conceptions of the good life, automobiles are not desirable, desire them though we presently do.

The point, again, is general, and I am following the philosopher Michael Luntley in making it:[21] absent conceptions of the good life, and mechanisms for their public airing, no genuine dialogue about automobiles—or education, the media, housing, health care, or any other matter affecting the *quality* of life—can occur; and the economic and political marketplaces of capitalism guarantee that they never will occur.

In proffering this general argument, I am attempting to simultaneously slay two different ideological dragons. The first of these is hard-line socialism, the view that freedom—active participation in discussions affecting one's life—is a luxury the peoples of poor nations cannot afford. This view has always been morally dubious, but now, when the economic weaknesses of such systems have been made clear, it has become morally opprobrious; no one can any longer maintain that the amount of human suffering endured in those countries has been justified by results, economic or otherwise. This is not to say that there have not been many major accomplishments under Communist Party rule in poor countries,—especially in China—many more than the U.S. media ever reported to the American peoples; but it is

to say we cannot, on moral grounds, ever hope for such governments to continue or return.

My other dragon is the hard-line capitalist ideology of the rights-bearing autonomous individual as a given, wherein "freedom" is seen as doing pretty much as one pleases, so long as one has the money to do so; and the devil take the hindmost. Deng Xiaoping is currently sitting on both dragon thrones, and his successor(s) can be expected to do the same, which implies that the Chinese peoples will have some measure of the capitalist sense of freedom in the economic sphere, and no freedom is *any* sense of the term in the political; the worst of both worlds for the overwhelming majority of them.

For all of these reasons I conclude that a strong central government in China is a greater evil for the Chinese peoples than a multiplicity of more or less autonomous "little Chinas." How autonomous they ought to be, what kind of federal institutions should be kept for inter-regional affairs such as railroads, mails, economic resource management, and so forth, how the poorer regions would obtain the financial wherewithal necessary for overcoming their poverty— all of these and many others are important questions I cannot answer. I must also allow the distinct possibility that the "little Chinas" might all end up with their own Deng Xiaopings, Yang Shangkuns, and Li Pengs, and concomitant bloated bureaucracies. But even if all the fears attendant on regionalism were realized, I believe they would very probably result in less misery for the Chinese peoples than they currently endure, and will continue to endure in the future.

During eighteen hundred of the past twenty-two hundred years China has been more or less unified. The concept of "All under Heaven" or "All within the Four Seas" goes back to the dim past. And tens of millions of Chinese must have felt proud when Mao announced on October 1st, 1949 (at Tiananmen Square) that "China has stood up." Yet much of the felt need for unity within stemmed from fears of invasion from without. One of the things the American peoples might do for the Chinese, therefore—and for themselves and the rest of the world as well—would be to reduce drastically the U.S. military juggernaut, so that the Cold War can truly come to an end, and armies the world over begin to shrink in size and importance. Under such conditions the Chinese fears of invasion should lessen, and be replaced by fear for their all-too-fragile-environment, and fear of continuing injustice, both economic and political; for the alleviation of which our moral hopes, it seems to me, should be for a number of smaller "Middle Kingdoms" whose citizens can struggle to achieve the good life as they collectively conceive and work for it.

If these reflections from a Chinese mirror are not badly distorted, they suggest that the Chinese peoples should no longer have, and do not need, a strong, monolithic Communist Party and central government. And they suggest as well that the Chinese peoples should not have, and do not need, Western industrial capitalism either.

Neither does anyone else.

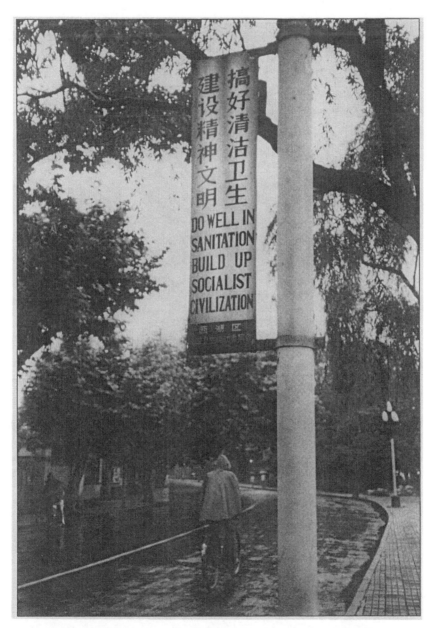

Street poster, Hangzhou, June, 1991.
Photo courtesy of Lisa Scheer.

Buddhist with watch. Shanghai, June, 1991.
Photo courtesy of Lisa Scheer.

Notes and References

I do not pretend that the citations and commentaries which follow incontrovertibly establish all of the more controversial interpretations, analyses, and evaluations made in the text, nor, again, do I wish to claim being an "expert" on contemporary China. The work is based largely on my personal experiences and observations over the years, and reflections thereon—a number of which appeared in *In These Times* from 1982 to 1984 under the heading "Shanghai Journal"—supplemented by readings which are available to everyone who has a good deal of time to search for them, and knows how to read them, and it is for this reason that I regularly cite the most accessible English-language document as my source.

Introduction

1. My antipathy to the standard television and print media should come as no surprise to anyone who followed Operation Desert Storm, for the media coverage made abundantly clear the extent to which they serve as the major propaganda arm of the U.S. government and major corporations. It is an apparent paradox that media which

are genuinely free to say whatever they wish should actually say so little. That many of the citations below refer to those media accounts is irrelevant: careful readers will see that I have regularly taken, for example, some material buried in the eleventh of a fifteen-paragraph article, material that is otherwise altogether ignored in that article—American journalism's paradigm of "balance," I fear. A full analysis of the U.S. media can be found in the many excellent writings on the subject by Noam Chomsky; no claims for originality are made for my views of the media, for at best, the present work provides a few footnotes in support of Chomsky's conclusions. While I recommend highly all of his writings, those that bear most directly on my arguments are: *Necessary Illusions* (Boston: South End Press, 1989), and, with Edward Herman, *Manufacturing Consent* (Boston: South End Press, 1990), *The Washington Connection and Third World Fascism*, and *After the Cataclysm* (Boston: South End Press, 1979). Among the alternative media from which I have learned much are *Z Magazine*, *In These Times*, the *Guardian*, *Resist Newsletter*, *Dollars and Sense*, *Left Business Observer*, and the *Nation*.

2. Grove Press, 1961.
3. To document all of the themes of these two pages would be to write out a bibliography of journalistic and scholarly writings on, about, and in modern China. There was not, of course, unanimity among the scholars and journalists themselves. A number of them did, and still do, come down more or less on the side of the Guomindang, and others did, and still do, come down more or less on the side of the Party; and still others have flipped from

one position to the other. Which writings were ignored, and which cited, and when, was largely determined by U.S. foreign policy decision-makers of the day. At one extreme, and a while ago, E.L. Wheelwright and Bruce McFarlane could suggest that the Chinese Communist Party as a party, could do no wrong, in their *The Chinese Road to Socialism* (New York: Monthly Review Press, 1970). At the other extreme, and more recently, Steven Mosher's *The Broken Earth* (New York: The Free Press, 1984) suggests just as strongly that the Party has never done anything right. Many of the ups and downs of "China-watching" can be discerned in the career of John King Fairbank, whose views have regularly served as an ideological lightning rod. He has been, at different times, castigated by the left, the right, and the center in the U.S., and by both Beijing and Taipei as well. He therefore has earned the right to tell his own tale: *China Watch* (Cambridge, MA: Harvard University Press, 1987). If only one book could be read about the manifold problems of modernization facing the Chinese in this century, my own preference would be Michael Gasster's *China's Struggle to Modernize* (New York: Alfred A. Knopf, Inc., 1983); for the U.S. side, on ideology and scholarship, Paul Cohen's *Discovering History in China: American Historical Writing on the Recent Chinese Past* (New York: Columbia University Press, 1984), is an incisive study.

4. This hope will seem naive and/or idealistic to the more pessimistically inclined, and so, probably, will the presuppositions on which it is based. I believe that if the full extent of the poverty of the Chinese peoples, and other poor peoples, were known to Americans, if it were

known as well that the poverty is linked, at least in part, to our wealth, then the American people would be willing to contemplate reducing the purely quantitative dimensions of their lives, and turn more to the qualitative dimensions, which I will take up in Chapter IV. Seemingly at odds with this view is the fact that U.S. polls consistently show the unpopularity of tax increases in this country; Americans no longer appear willing to assist even their own unfortunate, not to mention the poor of other countries. But the average auto worker, secretary, bricklayer, and so forth, know full well that many U.S. millionaires pay less in taxes annually than they do, and that a staggering amount of their tax monies are used to purchase $600 toilet seats for the military, finance ski trips for presidential advisers, and to compensate some greedy and/or incompetent S and L investors because of the greed and/or incompetence of the managers of their monies. Hence my second belief: if the American peoples could somehow be assured that all of the monies derived from a tax increase would go *directly* to the poor, the sick, the homeless, and the illiterate in this country, they would overwhelmingly vote for it; and further, I believe that once we began to overcome poverty and injustice in this way at home, the American peoples would be willing to continue to pay those taxes to assist in overcoming poverty and injustice elsewhere in the world. The same can be said for politics: it is not unusual for voters to be "apathetic" when their choices are limited to Tweedledee or Tweedledum. Cf. "American Voters Feel Shut Out of Politics," *China Daily*, June 12, 1991.

Chapter I: Yesterday (June 4th, 1989)

1. The standard picture of the events of the "Beijing Spring" described herein was taken from the TV coverage I saw before going to China on May 28th, and after returning June 10th, plus the videotapes I watched that friends had made, and kindly lent to me. For the print media, I drew largely, but not solely, on the *New York Times* and the *Washington Post*, and from such journals as *Newsweek* (especially the issues of May 29 and June 12), *Time* (June 19), *The Far Eastern Economic Review* (June 15), and *The New York Review of Books*. The best analyses of the images generated by these events and their media coverage is Joseph Esherick and Jeffrey Wasserstrom, "Acting Out Democracy: Political Theater in Modern China," in the *Journal of Asian Studies*, vol. 48, no. 4, November 1990, which is necessary reading for Wasserstrom's more in-depth study in progress, "Fashioning Narratives of Tiananmen: 1989 as Tragedy and Romance," a draft of which I am grateful to Wasserstrom for sharing with me. I also profited greatly from Arif Dirlik and Roxann Prazniak, "Socialism Is Dead, So Why Must We Talk about It?" which I read in manuscript, to appear in the *Asian Studies Review*.
2. *Washington Post* editorial, December 8, 1989.
3. Salisbury's remarks are taken from his *Tiananmen Diary* (Boston: Little, Brown, & Co., 1989—also cited by Mirsky (see below, note 6)—and from Salisbury's interview on the "MacNeil-Lehrer News Hour" of June 20, 1989.
4. *New York Times* editorial, May 23, 1989.

5. As described *very* briefly in most of the media materials cited in note 1.

6. Jonathan Mirsky, "The Empire Strikes Back," *New York Review of Books*, February 1, 1990.

7. From the book of that title by the ex-Communist-turned-arch-conservative Karl Wittfogel (Yale University Press, 1957).

8. The full text of Chen Xitong's report was translated and reprinted in the *China Daily*, July 7, 1989. See also note 23.

9. I first described these observations in a short article for *In These Times*, July 17, 1989, and in a longer *Z Magazine* piece, March 1990. This scene was re-enacted in a park in Hangzhou in June 1991, with my wife and a colleague present.

10. *China Daily*, June 4, 1989.

11. For a fuller account of the "Cultural Contamination" campaign of Autumn 1983, see my "Shanghai Journal" in *In These Times* for December 14, 1983.

12. Brenda Christian, "Porn Providing Perfect Target," *China Review*, January 1990.

13. *Seriatim: China Daily*, December 15, 1989; *Beijing Review*, September 18, 1989; *China Daily*, June 6, 1989; *China Daily*, December 18, 1989; *China Review*, January 1990; *China Daily*, April 25, 1991.

14. "Kidney Transplants in China Raise Concern about Source," *New York Times*, June 3, 1991.

15. Taken from two unrelated accounts given to me in China in June 1991, one by an American couple there, going through the process, the other from a Chinese in-

volved—for moral reasons—as a "middleman" between the orphanages and prospective foreign parents.

16. "Efforts Urged to Fight Smuggling," *China Daily*, April 25, 1991. By U.S. standards, the amount of drugs confiscated was trivial: 30 kilograms. But perhaps 30 kilos is a lot, where none were before.

17. A number of questions surrounding the famines of 1959 and 1960 will probably never be satisfactorily answered: how many people actually died? Did the government know the extent of the famine? If so, how did they cover it up, and what, if anything, did they try to do about it? How much of the blame for the famines rests with the droughts of those years, and how much with the central government? Given official U.S. antipathy to China at the time, why weren't the horrors of the famines broadcast in the U.S.? Amartya Sen accepts the figure of 30 million deaths during this period, and I am inclined to accept the figures, horrible as they are, that he accepts. See his "How Is India Doing?" in the *New York Review of Books*, December 13, 1982.

18. *New York Times* (International Edition), December 7, 1989.

19. The theme of how many Chinese students and scholars have or have not returned to China after completing their studies and research runs through most of the articles in *China Exchange News*, vol. 19, no. 1, Spring 1991.

20. Merle Goldman, "Vengeance in China," *New York Review of Books*, November 9, 1989. A more revealing analysis is "It's a Whole New Class Struggle" by Anita Chan and Jonathan Unger in the *Nation*, January 22, 1990.

21. A long and sorry tale. An early account is Mu Fu-sheng

(a pseudonym), *The Wilting of the Hundred Flowers* (Westport, CT: Praeger, 1963). Other useful works—among many—include Merle Goldman's *China's Intellectuals: Advise and Dissent* (Cambridge, MA: Harvard University Press, 1981); Jonathan Spence, *The Gate of Heavenly Peace* (New York: W.W. Norton & Co., Inc., 1980); Cheng Nien, *Life and Death in Shanghai* (New York: Collins, 1986) is a more personal account.

22. The incredible statistics on education among Party members were compiled by Laszlo Ladany, and cited by Peter Harris in "Taking Stock in the Nineties," *China Review*, January 1990. Ladany's figures were for 1985, which is why his figure of 42 million Party members may appear low; a large number of intellectuals began joining the Party in the early 1980s, and some estimates of Party membership now run as high as 47 million.

23. In a *Bulletin* issued June 24, 1989, Asia Watch reported that 27 executions had taken place in the aftermath of June 4th, and I read of 15 additional executions thereafter (but none after September 1989). For the killings in the Square, a first figure of 20,000 (Voice of America broadcast June 4, 1989) was as outrageously wrong as the government loudspeakers in Beijing which blared out the following day that there had been no bloodshed at all in the Square (and see *Newsweek*, June 19, 1989). In his official report to the Standing Committee of the Seventh National People's Congress on June 30, 1989 (see note 8) Chen Xitong said ". . . more than 6,000 martial law soldiers, armed police, and public security officers were injured and the death toll reached several dozens." As for the demonstraters, he reported ". . . more than

3,000 civilians were wounded and over 200, including 36 college students died during the riot." (*China Daily*, July 7, 1989). Figures almost identical to Chen's, unsurprisingly, were reported in the *Beijing Review* for September 18, 1989. The *New York Times* reported on June 21, 1989 that 12 soldiers and policemen, and between 400 and 800 workers and civilians had been killed, according to the best estimates. Far and away the best account of events in the Square on that fateful evening and following morning is Robin Munro's "Who Died in Beijing, and Why," in the *Nation*, June 11, 1990, but Munro does not give overall numbers of deaths. I would dislike having to defend any specific set of figures proffered for the casualties, but if pressed, would support those given to me by several Chinese friends when I returned to the country in December 1989: between 40 and 80 students, 100 and 150 soldiers of the PLA, Peoples's Armed Police, and Public Security officers, and anywhere from 700 to 1,200 workers and *laobaixing*, were killed between June 3rd and 5th in Beijing and its suburbs.

24. Aryeh Neier's column in the *Nation*, June 3, 1991.
25. *Washington Post*, January 6, 21, 28, and April 28, 1991. See also *News from Asia Watch*, January 17 and March 13, 1991.
26. The later figures I recorded in May 1989 in Beijing. The earlier figures were reported in two of my "Shanghai Journal" articles for *In These Times*, December 15, 1982, and February 2, 1983.
27. For over four years now, the *China Daily* has averaged about an article a week on bureaucratic corruption in the country.

28. *China Daily*, December 15, 1989.
29. *China Exchange News*, vol. 17, no. 1, March 1989, p. 21. See also the citations to William Hinton's work in the following chapter.
30. See Goldman, "Vengeance in China," *op. cit.* and Yue Daiyun and Carolyn Wakeman, *To the Storm* (Berkeley, CA: University of California Press, 1985).
31. The government repeatedly showed videotapes purportedly showing the violence of the mob, and restraint on the part of the PLA, in the days following the slaughter. But see Robin Munro's account in "Who Died in Beijing, and Why," *op. cit.*, esp. p. 815.

Chapter II: Today

1. Reports of difficulties in all these areas are given almost daily. The figures from and on the Polish government were taken from the *Washington Post*, January 12, 1991, the Business section. And the situation in that country is not improving. See "Relief Is Urgent, Poland Tells Banks," *International Herald Tribune*, June 5, 1991.
2. See notes 21 and 22 from Chapter I. But see also Chapter IV, p. 81.
3. To give only a few quick examples: "Is There a Reformer in China's Future?" by Nicholas Kristoff in the *New York Times*, June 17, 1990; "CIA: China's Stability Threatened," and "Chinese Leaders Argued over Fang's Release," from the *Washington Post*, June 29, 1990.
4. As Alexander Cockburn put it in his *Nation* column, June 12, 1989.

5. I will respond to the idea of political liberalization below, but the response should not be construed as any kind of defense of political authoritarianism. See also Chapter IV for additional arguments.

6. Robert Pollin and Alexander Cockburn, "The World, The Free Market, and The Left," in the *Nation*, February 25, 1991.

7. On lending by the banks, see the *Washington Post* Business section for April 28, 1991. Joel Bleifuss quoted the Nigerian Ambassador in his column for *In These Times*, August 29, 1990. That Japan is already beginning to have a "cash-flow" problem is suggested by Marcus W. Brauchli in a recent *Asian Wall Street Journal Weekly* article (June 3, 1991). He bears quoting:

> For the first time since World War II, the ever-expanding money machines that financed much of Japan's remarkable postwar economic miracle and came to represent the country's financial prowess went into reverse. Under intense pressure to expand the relative proportion of capital to assets, all but two of the country's 11 major commercial banks ended up slashing outstanding assets in the year ended March 31. The cutback was 13.8 trillion yen (100.11 billion)— the equivalent of more than Thailand's entire gross national product. According to banks and analysts, it is a trend that probably will continue.

8. *Washington Post*, April 28, 1991. For contrast, only $20 billion was invested altogether in China during the twelve-year period 1979 to 1990; see *Asian Business*, April 1991.

9. James Stodder makes the same point with reference to the U.S.S.R. in his "Soviet Union Scrambles to Privatize from Scratch," *In These Times*, May 15, 1991.

10. William Hinton, *The Great Reversal* (New York: Monthly

Review Press, 1990). I reviewed the book in *In These Times*, September 9, 1990.

11. *Ibid.*, p. 60. For the difficulties the Chinese face in even maintaining the current amount of arable land, see "Plan Aims at More Farmland," *China Daily*, June 13, 1991.

12. *Ibid.*, p. 16.

13. *Ibid.*, p. 112–13.

14. Victor Nee and Su Sijin, "Institutional Change and Economic Growth in China: The View from the Villages," in the *Journal of Asian Studies*, vol. 49, no. 1, February 1990, p. 6. Nee and Su also describe a number of weaknesses of the collective system, but their reports and analysis should be read alongside Hinton's, *op. cit.*

15. Hinton, *op. cit.*, p. 71.

16. As reported in *Time*, April 8, 1991, which also gives the figures for the Amur leopard pelts, and the pandas.

17. *Asian Business*, April 1991.

18. Vaclav Smil, *The Bad Earth* (Armonk, NY: M.E. Sharpe, Inc., 1984), pp. 100–101. See also "China Cleans Up Its Act but More Must Be Done," *China Daily*, June 5, 1991.

19. *China Daily*, April, 26, 1991. The article continues with the fairly dire prediction of North China suffering a water shortage of 28 billion cubic meters by the year 2000.

20. I kept the "man" in this quote intentionally: women are losing out in the "individual responsibility" system. In one province alone, for example—Henan—there are over 800,000 officials of all kinds, but only 6,000 are women; less than 1 percent. *China Daily*, March 30, 1991.

21. The exodus from the countryside has been increasingly rapid in recent years, making it impossible to provide

social services adequately. This contrasts sharply with earlier policies concerning population shifts. During the first two decades after Liberation, for example (1949–1970), the percentage of the total population living in urban areas only rose from 10.6 to 16.8 percent. Sendou Chang, "The Changing System of Chinese Cities," *Annals of the Association of American Geographers*, vol. 66. no. 3, September, 1976.

22. See Hinton, *op. cit.* Two bumper crops in a row have mitigated these circumstances, but perfect weather—seldom seen in China—helped a great deal. See note 2 to Chapter IV.

23. It should also be noted that no Western philosopher, in building ideal states conceptually, ever worried about there being enough of the basic necessities to go around for everyone. *All* Chinese philosophers have had to take this as a basic issue, from before Confucius to Mao Zedong. For a different vision of the "good society" thus arrived at, see my "State and Society in the *Hsun Tzu*" in *Monumenta Serica*, vol. XXIX, 1970–71.

24. *San Francisco Chronicle*, March 13, 1991, the Briefing section, and *China Daily*, June 12, 1991.

25. As quoted by Andrew Horvat in "By the Book or the Comic," *Far Eastern Economic Review*, June 20, 1991.

26. Amartya Sen, "Indian Development: Lessons and Non-Lessons," in *Daedalus*, vol. 118, January 1989. The best analysis of the "moral/economy *vs.* rational profiteer" debate is Andrew B. Chovanes, "On Vietnamese and Other Peasants" in the *Journal of South East Asian Studies*, vol. XVII, no. 2, September 1986.

Chapter III: Interlude: Modern Western and Ancient Chinese Concepts of the Person

1. Portions of this chapter are taken from my "Rights-Bearing Individuals and Role-Bearing Persons" in *Rules, Rituals, and Responsibility: Essays Honoring Herbert Fingarette*, edited by Mary I. Bockover (La Salle, IL: Open Court, forthcoming 1991), which contains additional references.

2. The discussions which have contributed to the second-order account of abortion touched on here and below are Judith Thomson, "A Defense of Abortion," in *Philosophy and Public Affairs*, vol. 1, 1972; Mary Anne Warren, "On the Moral and Legal Status of Abortion" in the *Monist*, vol. 57, 1973; L.W. Sumner, *Abortion and Moral Theory* (Princeton, NJ: Princeton University Press, 1981); and David B. Wong, *Moral Relativity* (Berkeley, CA: University of California Press, 1984). With the possible exception of Wong, however, it is doubtful that any of the other authors cited here would concur with what has been said in the text on this divisive issue.

3. See, for example, James Rachels, "Active and Passive Euthanasia," in the *New England Journal of Medicine*, vol. 292, no. 2, 1975.

4. Beginning philosophically with John Passmore's *Man's Responsibility for Nature: Ecological Problems and Western Traditions* (New York: Scribner's, 1974); and now a major and diverse field of study.

5. A now somewhat dated, but still useful, anthology is Tom Regan and Peter Singer, editors, *Animal Rights and Human Obligations* (Englewood Cliffs, NJ: Prentice-Hall,

1976); and there is much more recently written by both editors, and many others.

6. Contrast John Rawls, *A Theory of Justice* (Cambridge, MA: Harvard University Press, 1971), and Robert Nozick, *Anarchy, State, and Utopia* (New York: Basic Books, 1974). A cottage industry among philosophers has grown up around attempting to refute the major claims of one or the other of these works, and/or to reconcile them; altogether unsuccessfully thus far. A good critique of these kinds of disputes (and others) is in Alasdair MacIntyre's *After Virtue* (Notre Dame, IN: University of Notre Dame Press, 1981).

7. I have attempted to address the problems of cognitive and moral relativism in my "Against Relativism," in *Interpreting Across Boundaries*, edited by Gerald Larson and Eliot Deutsch (Princeton, NJ: Princeton University Press, 1988).

8. Some of the issues on these pages are also taken up—to differing conclusions—by A.J. Milne in his *Human Rights and Human Diversity* (Albany, NY: SUNY Press, 1985). The Preamble to the U.N. Declaration begins the book, p. 2.

9. Most notably Richard Rorty, beginning with *Philosophy and the Mirror of Nature* (Princeton, NJ: Princeton University Press, 1979) through his recent *Contingency, Irony, and Solidarity* (Princeton, NJ: Princeton University Press, 1989). Rorty does not believe, or urge, that all philosophers give up their jobs; rather does he minimally more modestly suggest that they see themselves as "edifiers" rather than truth-seekers.

10. The arguments of the preceding two pages are taken from my "Who Chooses?" in a *Festschrift* I edited for Angus C. Graham, *Chinese Texts and Philosophical Contexts* (La Salle, IL: Open Court, 1991), which contains citations.

11. "Against Relativism," *op. cit.*

12. Beginning in its present form with Mancur Olson, *The Logic of Collective Action* (Cambridge, MA: Harvard University Press, 1965). A discussion of efforts to solve the paradox is in *The Politics of Private Desires*, by Michael Laver (New York: Penguin, 1981).

13. Translated by Henry Rosemont, Jr., and Daniel J. Cook (Honolulu, HI: University of Hawaii Press, 1977).

14. A fuller statement is in my *Classical Confucianism and Contemporary Ethics* (La Salle, IL: Open Court, forthcoming 1992). See also David Hall and Roger Ames, *Thinking Through Confucius* (Albany, NY: SUNY Press, 1987).

15. *Ibid.*

16. John Donne, Meditation XVII.

Chapter IV: Tomorrow?

1. "Chinese Scholars Ignore Indoctrination," *Washington Post*, July 22, 1990, p. A22.

2. Despite these harvests, overall economic growth slowed from 1988 to 1990 from 11.6 percent to 3.8 percent. *Asian Business*, April 1991.

3. Recent conferences of and about Chinese dissidents in the U.S. were held in Honolulu and Washington, and were reported at length in the *Far Eastern Economic Review* of

June 6, 1991: "Home Thoughts Abroad," and "Talking Up a Storm." An Op-Ed piece in the *International Herald Tribune*, by Wan Runnan, one of the leading dissidents, had this to say: the Chinese government must "vigorously promote economic reform, to assure the transition to a market economy" (June 5, 1991)—music to the ears of the conservative American Enterprise Institute, which sponsored the Washington gathering of the dissidents.

4. As reported by Lena Sun in the *International Herald Tribune*, June 5, 1991. She wrote on similar themes for the *Washington Post* on June 2, 1991.

5. It is commonly believed that the U.S. was not a true imperialist power in the late nineteenth and early twentieth centuries, and John Hay's "Open Door" notes, rejecting the notion of spheres of influence, is cited as proof of this view. Thomas J. McCormack has argued, however, that the reason why U.S. foreign policy makers wanted all trading doors to remain open, was the realization that before much longer, U.S. industrial capacity would far exceed that of England and other imperialist countries, and that the United States could look forward in the near future to having all of China as its market. See McCormick's *China Market* (New York: Quadrangle [Times Books, Division of the New York Times Co.]; distributed by Harper and Row, New York, 1967), esp. pp. 128ff.

6. From the moment he entered office, so that he hadn't yet read *The Rise and Fall of the Great Powers* (New York: Random House, 1987, by Paul Kennedy).

7. I make this point with some diffidence, because a breakup of the U.S.S.R. has also been suggested as a good

thing by such arch-conservatives as A.M. Rosenthal of the *New York Times*, and Richard Nixon. Our views nevertheless rest on very different grounds, and their focus is on America, whereas mine is more on the Soviet peoples. Rosenthal's Op-Ed piece appeared in the *Times* on June 3, 1991, and Nixon's was in the Outlook section of the *Washington Post* a day earlier.

8. A good study of this issue, and Mao's role in it, is Dorothea A.L. Martin, "Raising Some Questions on Decentralization and Decentralization in China's Transition to Socialism," unpublished ms., Appalachian State University. The analysis of Mao here is my own. Although there are a large number of recent books on his thought, I still believe *History and Will* (Berkeley, CA: University of California Press, 1973), by Frederic Wakeman, Jr., is the *locus classicus*.

9. *The Great Reversal, op. cit.*, p. 135.

10. *Ibid.*, p. 128.

11. See Victor Nee and Su Sijin, *op. cit.*, for the positive correlation with economic well-being and the maintenance of public works projects.

12. Raymond Wylie, "Shanghai Dockers in the Cultural Revolution: The Interplay of Political and Economic Issues," in *Shanghai: Revolution and Development in an Asian Metropolis*, edited by Christopher Howe (Cambridge: Cambridge University Press, 1981).

13. Much of the dog-eat-dog horrors of Chinese rural life during the Cultural Revolution is narrated by William Hinton in his *Shenfan* (New York: Random House, 1984). Richard Madsen provides a cogent explanation for the horrors Hinton describes, my only quarrel with

Madsen being that he would continue to use a strong central government as a cure, whereas I read his work to conclude that such a government was a large part of the disease. In any event one should read his "The Politics of Revenge in Rural China During the Cultural Revolution" in *Violence in China* (Albany, NY: SUNY Press, 1990), edited by Jonathan N. Lipman and Stevan Harrell; the Editors' Introduction is also worthwhile reading.

14. Much of what is politically at stake in talk of the "good life"—substance rather than procedure with respect to justice—is discussed carefully and at length by Michael Luntley, *The Meaning of Socialism* (La Salle, IL: Open Court, 1989). I have taken much from this book in the pages to follow. Equally worthwhile reading on participatory democracy is Robert Paul Wolff, *In Defense of Anarchism* (New York: Harper and Row, 1976).

15. That Mao relied on these ideals in organizing the peasants in the 1930s is well described in Edward Friedman's *Backward toward Revolution* (Berkeley, CA: University of California Press, 1974).

16. Kenneth Hale, "The Human Value of Local Languages," unpublished ms., MIT. Needless to say, there is a great deal of linguistic diversity in the USSR as well, not to mention Yugoslavia, or India.

17. The plight of the Tibetans is regularly being documented now, and the reports are assembled bi-monthly by the International Campaign for Tibet, published as *Tibet Press Watch* (1511 K Street, N.W., Suite 739, Washington, DC 20005).

18. The same may be said for the U.S. A lengthy article in the *San Francisco Chronicle* for March 13, 1991, condenses

a number of environmental studies and cites figures that inescapably lead to the conclusion that consumption of all kinds in the capitalist industrial democracies is going to have to be reduced significantly in the near future.

19. China's road figures come from *Asian Business*, April 1991; America's are taken from the *Hammond Medallion World Atlas* (Maplewood, NJ: Hammond, Inc., 1974), extrapolating therefrom.

20. The negative features of "the automobile age" are beginning to be well known. For some specifics see, for example, the *San Francisco Chronicle*, March 13, 1991, or the *London Independent*, May 13, 1991.

21. *The Meaning of Socialism, op. cit.* Much of the discussion of automobiles is taken from my "Foreword to the American Edition" of that work. For a broader vision, see *Reweaving the World: The Emergence of Ecofeminism*, edited by Irene Diamond and Gloria Feman Orenstein (San Francisco: Sierra Club Books, 1990).

Index of Names

Index of Subjects

CPSIA information can be obtained at www.ICGtesting.com
Printed in the USA
LVOW090744120112

263540LV00002B/13/P